YOU
YOUR

CW01401822

A COLLECTION OF TEXTS AND MEDIA
ON THE WORK OF CHRIS KRAUS

EDITED BY MIRA MATTAR

MUTE BOOKS

Mute

Mute Publishing - London | Berlin
http://metamute.org | @MuteMagazine | services@metamute.org | simon@metamute.org

Mute Books is an imprint of Mute Publishing
ISBN eBook: 978-1-906496-63-0
ISBN print: 978-1-906496-64-7

Free to download as an eBook and available in print through pay channels http://metamute.org/editorial/books/you-must-make-your-death-public

Acknowledgements

Editor Mira Mattar
Design Layout Raquel Perez de Eulate
Publishing Management Simon Worthington
eBook Layout and Design Template Loraine Furter
Cover Image Reynaldo Rivera

The title of this book is a reference to Squat Theatre's play *Andy Warhol's Last Love* quoted in Chris Kraus' *Aliens & Anorexia.*

Thanks and an appreciation of support are due to the Critical Writing in Art and Design programme at the Royal College of Art London, David Crowley, Travis Jeppesen, Christina Kral, Julia Rehfeldt, Johannes Amorosa, Anthony Iles, Josephine Berry Slater, Hestia Peppé, Karim Mattar, Michael Reid, Lidija Haas and Julia Calver.

Chris Kraus texts referenced in this book:

I Love Dick, USA: Semiotext(e) / Native Agents, 1997.

'Deep Chaos', (1999), *Video Green: Los Angeles Art and the Triumph of Nothingness*, USA: Semiotext(e) / Active Agents, 2004.

Aliens & Anorexia, USA: Semiotext(e) / Native Agents, 2000.

'Emotional Technologies', (2000), *Video Green: Los Angeles Art and the Triumph of Nothingness*, USA: Semiotext(e) / Active Agents, 2004.

'The Blessed', (2000), *Video Green: Los Angeles Art and the Triumph of Nothingness*, USA: Semiotext(e) / Active Agents, 2004.

Video Green: Los Angeles Art and the Triumph of Nothingness, USA: Semiotext(e) / Active Agents, 2004.

Torpor, USA: Semiotext(e) / Native Agents, 2006.

'Stick to the Facts', *Texte Zur Kunst*, Issue no. 70, May 2008.

Where Art Belongs, USA: Semiotext(e) / Interventions Series, 2011.

Summer of Hate, USA: Semiotext(e) / Native Agents, 2012.

CONTENTS

FOREWORD

TRAVIS JEPPESEN

1997 was a watershed year in American writing. It was the year that saw the death of both Kathy Acker and William Burroughs, arguably the two most iconoclastic voices in late 20th century fiction. Yet it could also be said that it was the year that saw the emergence of one of the most uncompromising and important voices of the 21st century; it was, after all, the year that a book called *I Love Dick* came out.

Prior to this moment, Chris Kraus was a largely unknown figure to those outside of New York's downtown art scene, where, throughout the previous two decades, she had etched out a somewhat peripheral existence as a film-maker – an experience she would later write about in her 2000 novel *Aliens & Anorexia.* Yet Kraus was also active on the literary scene, befriending the poets who hung out at the St. Mark's Poetry Project, and launching the Native Agents series for Semiotext(e). This posited a parallel between the critical theory coming from the Continent – much of which was being published for the first time in English – and some of the more renegade voices in American poetry and fiction of the period; many of them women writers who, in the traditionally male dominated, heteronormative world of the intellectual and literary avant-gardes, had had to struggle to reach their audience.

With *I Love Dick,* Kraus finally began to speak in a language very much her own. Sixteen years and six books later, it is a language we are still coming to grips with. How, after all, does one go about summing up a sensibility animated by such a ruthless, anarchic deployment of subjectivity? A style marked by an effortless movement across vast strata of subject matter and ideas, whose sole vehicle is the 'I'?

Here in the UK, where heated discussions of 'art writing' have been raging for the last few years, Kraus' work has taken on particular significance, as all of her writing

– whether she is writing a novel or for an art magazine – works to eradicate the artificial border separating fiction from criticism. At the same time, one might suggest that we have only begun to understand the questions and challenges Kraus' writing presents and its implications for the larger scene of art criticism, in its present and future forms. Is there a battle going on today between form and content in art writing? What are the implications of mapping such a battle across the ever shifting co-ordinates of gender?

The symposium I organised in 2013 on Kraus' work at the Royal College of Art, London together with my colleagues in the program for Critical Writing in Art and Design, represented one effort to begin answering those questions. I'm happy that the contributions from that symposium will now find greater circulation.

INTRODUCTION

MIRA MATTAR

Chris Kraus is her own case study, her own case in point. She is her own most immediately available raw material and she is not ashamed.

What does it mean that writer and film-maker Chris Kraus treats herself like this? That she speaks about herself? And what makes this speaking about self more interesting and dangerous than autobiography, memoir or confession? What distinguishes it from notions of *écriture féminine*?[1] Is it simply that her work combines elements of fiction, art criticism and political commentary? Are the things which make it dangerous also those which make it unclassifiable?

Since her first book, *I Love Dick*, published in 1997, Kraus has authored a further six books alongside co-editing Semiotext(e)'s Native Agents series. Kraus launched Native Agents in 1990 in response to Semiotext(e)'s publication of mostly male, Continental post-structuralist theorists, wanting instead to promote predominantly female non-mainstream writers engaged in 'an enactment of the theories of subjectivity found in French theory'.[2] Like many writers published by Native Agents, Kraus' own deployment of such theories renders her texts unwieldy and resistant to categorisation. Post-structuralist theory finds a living correlate and antagonist in a set of literary practices.

While this text is not the place to tackle the problematic term 'art writing' it can be said that it has provided some space for the more uncategorisable elements of contemporary writing. Perhaps it is no surprise then that a significant engagement with Kraus' work, the two day symposium in March 2013 which this book documents, took place under the auspices of an 'art writing' programme – Critical Writing in Art and Design at the Royal College of Art, London.

Though 'art writing' may provide a platform for work such as Kraus', perhaps 'writing', plain and simple, untethered to any single mode, is a more suitable, less loaded descriptor. Eschewing borders between modes of writing that tend to dictate and bind content, Kraus instead uses her own biography to stitch together a wide range of material, resulting in unconstrained, disobedient texts. This quality of unboundedness was reflected in the various modes of presentation at the not-strictly-academic symposium – there were papers by artists, writers and academics; video-essays; collaborative presentations and performances.

Unmediated by genre, literary games, and devices like metaphor and allegory, Kraus' writing functions more like transcription. Writing as verb, as witness report of the present moment. This is what makes it dangerous – Kraus insists on speaking the unspeakable now, a contemporaneity for which there is no suitable form. But instead of this meaning it cannot be spoken, it means quite the opposite: that it must be. And it is only through an unashamed subjectivity that it can be.

But this witnessing of the present moment must be reflexive. Kraus' is not the cool eye of the writer-outsider, privy to some special perspective which excludes itself – in fact it is applied most unflinchingly to itself. Such a procedure requires an objectivity that is as free of shame as it is of pride. This stance, which sets her apart from proponents of *écriture féminine*, is the crucial point upon which much of the work contained here turns.

Shamelessness is key in making the personal political, the private public, without which neither release nor action are possible. Nothing is (only) personal. But this self-speaking must be distinct from confession, identified by Foucault as

an act of shame and guilt, laced with a plea for forgiveness –
insidiously compulsory at this moment in history. Instead of
confession, Karolin Meunier, in her essay, suggests candour.
Examining how Kraus' making-public of the apparently
private can function as feminist practice, Meunier analyses
Kraus' use of the personal as a tool with which to begin
writing and engaging with the world through art criticism,
political commentary and fiction. How can candid speech
about one's own experience allow for abstraction from it?
What starting point does the self offer?

Present throughout Kraus' *Aliens & Anorexia* (after
which the symposium was named) is Simone Weil's
imperative to use the body or self as 'a lever for salvation'.
Weil's formulation is crucial to David Morris' essay. Akin
to Meunier's anti-confessional candour, Morris offers
disclosure – a shameless facticity that is neither sensational
nor romantic – as the tool or lever with which to achieve
salvation. Morris studies Kraus' 'body' of work suggesting
it acts, particularly the letters comprising *I Love Dick*, as its
own archive. It complicates notions of privacy, persona,
authorship and autobiographical writing; ideas Jonathan
Lahey Dronsfield also explores in his text, comprised in
part of a cut up from *I Love Dick*. For Samira Ariadad the use
of the body as lever correlates directly with Kraus' interest
in depathologising anorexia and reframing it as a site of
protest enacted with the body.

Kraus does not recoil from the sick body, the humiliated
body, the body in love, the body in pain, the objectified body.
Indeed, in Beth Rose Caird and Jesse Dayan's project on *Where
Art Belongs* it is precisely the self's 'thingness' which must be
interrogated in relation to art production. What knowledge
might or might not arise when the critical gaze is turned
upon itself? What operations of objectivity are required to

perform this? Similarly, Linda Stupart argues for the power of positioning oneself as an object, as 'a thing that feels', in relation to Kraus' writing on the ritualised theatricality of S/m and its potential correlation with the dynamic between critic and artwork. Stupart proposes a more empathetic critical gaze, exchanged between feeling objects.

Empathy is positioned around a different axis in Hestia Peppé's work. By reading Kraus against Tiqqun's *Preliminary Materials for a Theory of the Young-Girl* (2012) Peppé asks whether we can, through reading and writing each other, begin to find a way out of Tiqqun's nightmarish proposal wherein we are all Young-Girls – that is, both conduits and victims of contemporary capitalism's pervasive violence. How can we become more, less and other than ourselves through the reception of experience in reading? This is not a comfortable empathy, it is not feeling *for*; it is a transformative empathy, feeling *with* to the point of becoming different. It requires a detachment from one's own boundaries of self in order to transgress them. A happy disregard for the integrity of the self, a necessarily public death of that self. Kraus, suggests Peppé, explores this in her texts partly through a playful and sophisticated use of first and third person narrators.

What kinds of non-normative girls, young or otherwise, do we find in Kraus' texts who could be the agents of these transformations? And conversely, asks Helen Stuhr-Rommereim, what kinds of normative power do we find the 'characters' in Kraus' 2006 book *Torpor* living under, depressed by and questioning? In her essay Stuhr-Rommereim contrasts queer temporality with 'chrononormativity' (signposts of a supposedly adult life: marriage, a house, children, a job that gets better etc.) to analyse notions of how success, failure, happiness and

sadness are perceived and presented according to different projections of time, tenses and places in *Torpor.*

In her video-essay on *Summer of Hate,* Rachal Bradley investigates Kraus' use of place as topology of class, not simply a background against which narrative plays out. Real estate, in which the novel's protagonist, like Kraus herself, deals, creates reality. Social relations are tethered to property and subjectivity is partly produced by the fluctuating relationships between place and capital. Equally attentive to these dynamics Lodovico Pignatti Morano and Trine Riel examine, in their video presentation, how place makes us but does not care who we are.

Such indifference, though sometimes unbearable, can be used to cultivate an unashamed and rigorously applied objectivity which might allow for a more precise transcription of the present and of the contemporary conditions for the production of subjectivity. Without this, there is no way out. To be done with the operations of shame which keep us silent, stuttering, tongue-tied, inarticulate, locked in the private; and undermined and humiliated in public. Taking an impersonal stance might hold within it the power to bring about a more elastic suturing between self (or selves) and world.

As a timely exploration of Kraus' writing I hope this collection will introduce a framework for thinking what might be at stake for fiction, art criticism and theory after Kraus. She has created space, both through her editorial work and by initiating unique possibilities of writing, for new writers to find a way in – or perhaps out. But superficial readings of her work may allow for a collapse back into its enemies – autobiography, confession, memoir. To avoid this, a continued engagement is required. I hope the works that follow will serve as a beginning.

Footnotes

1 Literally 'women's writing'. A current in 1970s post-structuralist French feminist literary theory proposing a mode of writing which, crudely put, allows for the female body and experience to be inscribed in its own language.

2 See *Lambda Literary*, 'Chris Kraus: *Summer of Hate*', 3 November 2012, http://www.lambdaliterary.org/features/11/03/chris-kraus-summer-of-hate/

A DELICATE TIME: QUEER TEMPORALITY IN *TORPOR*

HELEN STUHR-ROMMEREIM

Running Up That Hill

Time can be a torturous thing. The past few weeks, I've felt the crush of time as the date of this talk has crept closer, my orientation towards time has shifted as I've considered the trajectory of relationships old and new, as I've felt the push of my own ambition, and grappled with endings and beginnings, past, present and future. My time twists into distorted shapes, it creeps and stretches – and it always passes. This talk comes from a need to understand the diagrams around which a life is constructed, from the anxiety provoked by a perceived imperative to move along a progressive teleology of success or family life, from questions about how to reconcile with the objects of desire that pull us forward, backward and sideways in time. And all these questions of time have brought forward questions of happiness.

Happiness is slippery, and happiness is timely. Recent writings by theorists such as Sara Ahmed and Lauren Berlant[1] have connected happiness with the queer subject as one that both subverts and is unable to access traditionally established paths towards happiness. And this relationship with happiness is inextricably connected to time. E.L. McCallum and Mikko Tuhkanen argue in their introduction to the essay collection *Queer Times, Queer Becomings* that queerness, particularly in the West, is characterised as much by improper positioning with regard to time as with social norms.[2] And the two are intimately bound. This is evident when we consider, for example, that in Freudian terms, homosexuality is seen as regressive and indicative of an inability to orient towards the future appropriately – this future being one that should contain such signposts as marriage and children. McCallum and Tuhkanen point out

that this untimely relationship with normative temporality has been used against queer people, as indicative of a failure, essentially, to grow up. But they assert that discussing queerness as defined by asynchrony can, on the contrary, open up possibilities and be a space of hope.

Nietzsche writes in his second *Untimely Meditation*, 'On the Uses and Disadvantages of History for Life', that the progressive historical thinking that characterises our common relationships with time can 'cut off the strongest instincts of youth, its fire, defiance, unselfishness and love, at the roots, damp down the heat of its sense of justice, suppress or regress its desire to mature slowly with the counter-desire to be ready, useful, fruitful as quickly as possible...'[3]

For Nietzsche, progressive trajectories are at odds with all of the liveliness of life. McCallum and Tuhkanen identify the important potential for radicality in this argument as lying in Nietzsche's conception of what they describe as the 'individual cutting against the masses surging onward through history.' This is the individual uncoupled from commonly lived time. And it's important to note that while it might be radical, it isn't an easy position to be in.

This talk, most simply, is an exploration of queer time and its implications in relation to Chris Kraus' third novel, *Torpor*, which, as the title suggests, is marked by pervasive unhappiness and personal inertia. I'd like to work through the various ways that time is queer for Sylvie, the main character of the novel, by first looking at what it means for time to be lived queerly, and then with this in mind, examining how Sylvie is denaturalised from her desired and expected trajectory, how this causes pain and anxiety and a sense of loss and dissociation, and how she begins to resolve these feelings in a way that presents new questions

as to how and whether we should orient ourselves in time towards happiness.

In *Torpor*, Sylvie is a somewhat half-hearted film-maker and artist who hasn't achieved success professionally, and finds herself at something of a personal impasse. At 35, Sylvie is coming to terms with her present, and attempting to grasp her relationship with her future. Sylvie has trouble taking her own life seriously. Her husband Jerome is a 53-year old academic rebel and friend of the academic stars, and she and Jerome have constructed their relationship around the playing out of conversational games in which they take on proscribed roles vis-a-vis one another. It is these games that form the glue of their relationship, rather than progress through the typical signposts of a marriage: a house, a life in one place, children, grandchildren, etc. In *Torpor*, Sylvie exists in a web of lost potentials and imagined futures. Viewed from this perspective, the novel tells the story of her reconciliation with the impossibility of certain desired futures.

While discussions of queer temporality are primarily centred around reproduction, heredity and lineage, it's also worth noting that the kinds of teleologies of happiness that are teleologies of normative becoming are also very much implicated in conceptions of success and achievement – getting an education, having a job that leads to a better job, having a house, even reaching certain thresholds of health and beauty. This kind of progress to who-knows-where is expressive of the biopolitical condition of living as human capital, described in detail by Michel Feher,[4] in which one's relationship with the self is defined by speculative investment towards a point of future pay off which is necessarily never going to arrive. The absurdity of this speculation was reflected quite succinctly by Kraus herself,

when she wrote in her 2012 novel, *Summer of Hate*, of fellow academics who 'update their CVs and still believe they are progressing somewhere other than death.'

The connection between human capital and queer temporality becomes stronger when both are brought into a discussion of what it means to be happy and what it means to want to be happy. Thought of this way, it might be possible to find oneself living a life that is temporally queer in myriad ways.

Playacting

Elizabeth Freeman, in a special issue of *GLQ: A Journal of Lesbian and Gay Studies* from 2007 entitled *Queer Temporalities*, defined 'queer' as the set of possibilities generated from temporal and historical difference.[5] A temporal queerness is one focused on becoming, on particular pathways for becoming, and on representations and implementations of those pathways. Tim Dean describes the 'temporal turn' in queer theory as a shift in focus from representation towards the implications of lived asynchronocity in the intimacy of one's bodily being,[6] or in other words towards the affective experience of asynchrony.

This affective experience is the experience of tension with what Freeman terms chrononormativity. In her important monograph on queer temporality, *Time Binds: Queer Temporalities, Queer Histories* Freeman defines chrononormativity as 'the use of time to organise human bodies towards maximum productivity'.[7] Time, in other words, 'binds' us into particular forms of social embodiment.

In *Torpor*, Sylvie describes herself moving through her life as though acting in a film, bringing forward a sense of

separation from her lived reality. When she and Jerome go to Romania in a half-serious quest to find an orphan to adopt and make their child, Sylvie imagines how she will be like 'Sally Field in *Not Without My Child*', if she is unable to bring the child back to the United States. Embarking on their quest, she steps out of a cab with Jerome and hopes that her 'rhinestone glasses [will] throw the bourgeois respectability of [her] linen dress into insouciantly witty air quotes.' Later, Sylvie thinks, 'Jerome is the Tin Man, and she is Dorothy, searching for the ruby slippers. But at first glance, Romania is nothing like the Land of Oz.'

Sylvie's inability to feel sincerely engaged in the acts of normative life-building are a contemporary cousin to what Sara Ahmed, in her essay 'Happy Futures, Perhaps', describes as Mrs. Dalloway's condition, in Virginia Woolf's novel, of alienation from her own life. Ahmed writes,

> becoming Mrs. Dalloway is itself a form of disappearance: to follow the paths of life (marriage, reproduction) is to feel that what is before you is a kind of solemn progress, as if you are living somebody else's life [...] as if your life is going through motions that were already in motion before you even arrived.[8]

But Sylvie's experience is one of dissociation rather than disappearance. The 'motions that were already in motion' for Mrs. Dalloway are not in motion for her, and she struggles to imagine the other potential trajectories that might exist if the one she hopes for proves inaccessible.

Freeman writes, 'people whose individual bodies are synchronised not only with one another but also with larger temporal schemas experience belonging itself as natural.' Sylvie doesn't possess this natural sense of belonging. Her inability to let herself be pushed along by the current, her

sense of exclusion from the current, makes it impossible for her to take the actions necessary to have what she feels she wants – a child. There's a gap between her desire for a child and both the circumstances of her life and the way she relates to those circumstances.

Sylvie and Jerome's relationship with each other is asynchronous on a number of levels, not only in their age difference, and it's made to seem somewhat ridiculous in its asynchrony. Sylvie observes that, 'All these years, while she's giddily played the pert gamine Jerome could recast his guilty furtive youth with, she's noticed other people building actual lives they seemed to take quite seriously.' While other couples were 'building lives', Sylvie and Jerome have been playing games – like children. Even in their sex, Jerome and Sylvie's timelines are distorted. Kraus writes, 'When he makes her come, all this fucked-up gender stuff dissolves and she feels her body spinning backwards towards itself at different ages, 14, 11, once, she went back as far as 5.'

Here, the ultimate pleasure actually comes in the form of freedom from the necessity for a synchronous, forward-moving temporal existence. Sylvie, in her state of ecstasy, is flying all over time. Of course, it's not the kind of pleasure that can be sustained. Nonetheless, these games that Sylvie plays with Jerome seem more sincerely experienced than her attempts at the more normative processes that a couple might go through – like having a child. Though Sylvie's desire for a child might be sincere, neither she nor Jerome can actually imagine her as a mother. It's a role she is simply unable to act out. Sylvie and Jerome have had multiple abortions before they travel to Romania to adopt a child – with no preparation or plan for how they might actually carry out the adoption.

Sylvie asks herself early on in the novel, 'Why did the people closest to her find the thought of Sylvie having children so impossibly grotesque?', she continues, 'Her life will never have a value of its own apart from her achievements.' The child is seen as that which gives life 'a value of its own'.

It is difficult to pin down the precise reason why Sylvie is not mother material. In posing her 'achievements' against the possibility of a child, Kraus almost suggests Sylvie is suffering from the contemporary woman's desire to 'have it all' so celebrated as impossible in recent trend pieces in *The Atlantic*.[9] But there is something more going on here.

Sylvie's fraught relationship with motherhood is entrenched in the chrononormative conception of reproduction as the only way to progress through life. In their desires, in their mode of interaction with the world, Sylvie and Jerome are somehow separated from the naturalness of their lived experience and their bodies. Overgrown children, they are made ridiculous by their inability to engage on the same temporal scale as others of their age and position. Rather than the question of work/ life balance, it's the question of seriousness that plagues Sylvie throughout the novel. Ultimately, she chooses to give herself over entirely to play, embracing the supposed regression of a more queerly temporal existence, which is something I'll go into a bit more later.

If Only...

But time is twisted in *Torpor* not only in Jerome and Sylvie's disconnection from the proper narrative of their couplehood. Throughout the novel, Kraus employs explicitly

intentional tenses to express particular and shifting relationships with time. Discussions of queer temporality are discussions of lived experience, and the reading of *Torpor* is itself an experience of disorienting asynchrony – a constant negotiation of times and tenses, and a struggle to arrange narrative along a comprehensible trajectory.

Most of the novel is written in present tense, the tense of the lived moment moving forward – the now might change, but there is always a now. Simple past is used for the known unfolding of historical events. Sometimes the narrative skips forward into the inevitable future to come, employing the simple future tense. These futures are never ideal, and often depict the playing out of events in such a way as to prove the inevitability of endings, and the loss of anticipated possibilities.

Kraus writes in the final chapter, for example, 'The dog will die, and Sylvie will know she has to leave then. Still, it will be another several years before she leaves Jerome.'

But more painful than the simple future expression of undeniable loss, are the moments when these potentials were still alive as real possibilities.

In the final pages of the novel, discussing a failed academic who eventually committed suicide, Kraus writes,

there was a strange way Henri used to talk. He was never good at making plans. I mean – he never talked about himself as if there was a future, the way most people do. There was this funny tense he used, as if the future had already happened. He always said 'I would have been'.

The temporal centre of *Torpor* is anchored in the 'would have been', which Kraus describes in the book as 'a tense of longing and regret.' This centre is not where the action of

the novel takes place. It is rather composed of two images that come to represent Sylvie's particular lost future. One depicts pure fantasy, and the other captures a moment of romantic bliss filled with the potential for that fantasy to be fulfilled.

In a flashback to when Sylvie was still living the life of an artist in lower Manhattan, before meeting Jerome, she latches on to the image of a neon clock advertising Rheingold beer in a bar. That sign becomes the ever present image of the future that she will never possess. Kraus writes of the sign that it features 'an autumn scene, with two red setter dogs looking up above the blazing maples at a pheasant' – the sign presumably hails from the 1950s era of Rheingold signage that prominently featured happy women with dogs. I found some of these images on Google, and after reading *Torpor*, they take on a disturbing taunting quality, as if saying: this happiness is impossible.

In the moment when the Rheingold sign is introduced, Sylvie is remembering it while basking in the potential for her relationship with Jerome to play out along this desired timeline. It's autumn, and she's acquired the props that promise happiness: a dog, a car, a husband.

The second image is a photograph of Jerome and Sylvie at the height of their love for one another, when the game of being a married couple was still a fun one to play. It's a moment Sylvie revisits several times over the course of the novel. Kraus writes, 'The photo is a strange artefact: a souvenir of possibilities that never came to be... Take me anywhere, but take me now – it is a picture of complete abandonment... The woman in the picture is inescapably immersed in an expectant emptiness.'

This image captures a moment of believing in love, and expecting that love to guide along the established pathways, and bring something to fill the emptiness.

Empty Promises

But the Rheingold sign is an empty promise. In her book *The Promise of Happiness*, Sara Ahmed writes that the expectation of happiness provides a 'specific image of the future.' *Torpor* is full of what Ahmed calls happy objects – objects that are desired, waited for, and moved towards, and whose arrival is meant to bring happiness, and therefore good, pleasurable feelings. For Sylvie, the image of herself as the woman in the Rheingold sign, smiling with a dog, is the image of happiness – and it's an image so absurdly fantastic as to be a near caricature of the kind of orientation that Ahmed describes. But Sylvie looks back at the moment that held the possibility of happiness as her moment of ultimate happiness, all the more painful to remember for the loss it also implies.

But Ahmed questions the position of happiness as something desirable at all, suggesting that it functions rather as a way of confining people to proscribed ways of being. Ahmed writes, '[the] freedom to be happy restricts human freedom if you are not free to be not happy. Perhaps unhappiness becomes a freedom when the necessity of happiness is masked as freedom.'

So happiness, by guiding us towards certain objects, is restrictive in requiring us not to be unhappy with the acquisition of those objects, making unhappiness a failure or a deviance. To return this to the issue of speculative futurity in relation to the self, the imperative of self-optimisation inherent in the subject as human capital suggests happiness can be found in perpetual improvement, in a constant orientation towards the future as the place where things will be better, and better in a very specific way.

Ahmed tries to reconfigure these relationships. She writes, 'We can consider how we are affected by the arrival

of something in which we have placed our hopes. The boat that arrives might be empty, or it might be full. We do not know in advance of its arrival whether it is empty or full.' This something, this boat, might be marriage, it might be a child, a pet, or a job. In *Torpor*, the moment Sylvie always returns to in melancholic nostalgia is the moment when some of her boats have come to shore – she's married, she has a dog – and when she is fully expecting these vessels to carry with them further happiness. There is always some further step down the line. If she could just have a baby, then she would be happy. But, Ahmed continues,

> the point might be that we do not point our emotions toward the object of our cause [...] The boat might arrive or not [...] If it arrives, we won't know whether the boat will give us what we hope for. The boat will no longer be held in place as a happy object; the prospect of its fullness will not be the point of our journey.

Sylvie suffers from what Lauren Berlant terms 'cruel optimism', in her book of the same name. Cruel optimism is a relationship with Ahmed's happy objects that itself impedes access to that very thing that makes the object happy. To carry through Ahmed's metaphor, cruel optimism occurs when the act of waiting for those boats to arrive is what makes it impossible to have what the boats should bring.

The last chapter of *Torpor*, incidentally titled 'Better', sees Sylvie some years later, having left Jerome and established herself in LA, engaging in casual sex with various strangers that she finds in newspaper ads or via dating hotlines. Kraus writes, 'sex becomes a recreational pursuit, like playing chess. Appearance, common interests, politics become completely immaterial. [Sylvie] finds this

very liberating. So long as they are skilled and serious about the game, nearly anyone will do.'

This casual sex does not erase the desire for a baby, it is not, exactly, making Sylvie 'happy'. But, as Ahmed argues, happiness is always folded together with the potential for happiness. Sylvie's casual sex is perhaps an antidote to lost potential, as well as a way of opening up alternative potentials. Maybe this is an example of what Ahmed describes as finding freedom in unhappiness. Sylvie finds solace and satisfaction in sex that bears no suggestion of a future, no shadow of a narrative.

Of course she still yearns for the promise that her relationship with Jerome once held, and suffers in her separation from the temporal schemas that Freeman suggests provide a natural sense of belonging. Nonetheless, she is more in sync with herself living relationships as a game, than attempting marriage and family life.

The point is not that casual sex is more favourable than long-term, committed relationships or children, only that for Sylvie it offered a way out of what became a limiting and damaging relationship with the future. Ahmed argues for a somewhat un-happy openness to contingency as a means of lifting the binds of time that I've discussed – of progressive thinking, of object-oriented desire – to embrace pointless emotions and the implications of failure inherent in non-normative relationships with the future as good, and as full of possibility. In *Torpor* we see the pain of being excluded from certain teleologies, and the complicated re-orientations of desire that must take place in order to make that condition of exclusion first bearable and then potentially radical.

Footnotes

1 Sara Ahmed, *The Promise of Happiness,* Durham, NC: Duke University Press, 2010. Lauren Berlant, *Cruel Optimism,* Durham, NC: Duke University Press, 2011.

2 E.L. McCallum and Mikko Tuhkanen (eds.), 'Introduction', *Queer Times, Queer Becomings*, New York: State University of New York Press, 2011.

3 Friedrich Nietzsche, 'On the Uses and Disadvantages of History for Life', *Untimely Meditations*, Daniel Briezeal (ed.), R. J. Hollingdale (trans.), UK: Cambridge University Press, 1997. Quoted in *Queer Times, Queer Becomings*.

4 Michel Feher, 'Self-Appreciation; or, The Aspirations of Human Capital', *Public Culture*, 2009, vol. 21, no. 1.

5 Elizabeth Freeman, 'Introduction', *Queer Temporalities*, special issue of *GLQ: A Journal of Lesbian and Gay Studies,* 2007, vol. 13, no. 2-3.

6 Tim Dean, 'Bareback Time', *Queer Times, Queer Becomings*, op. cit.

7 Elizabeth Freeman, *Time Binds: Queer Temporalities, Queer Histories*, Durham, NC: Duke University Press, 2010.

8 Sara Ahmed, 'Happy Futures, Perhaps', *Queer Times, Queer Becomings*, op. cit.

9 See Anne-Marie Slaughter, 'Why Women Still Can't Have It All', *The Atlantic,* July/August, 2012, http://www.theatlantic.com/magazine/archive/2012/07/why-women-still-cant-have-it-all/309020/

BECAUSE BOTH OF US WERE GIRLS

HESTIA PEPPÉ

As an artist working in performance and various technologies including writing and social media, I have the specific fortune to earn my living as a private tutor, a governess. I am not currently an academic but I'm approaching this paper as an opportunity to talk about what I see as the possible use in practice of the work of Chris Kraus in terms of a performative philosophy. It's a real honour to be able to do so.

The Figure of the Young-Girl

As a governess I work with a lot of young girls, not the underprivileged community project kids you often hear of artists working with, regrettably I cannot afford to do that. I usually work for the exceptionally wealthy. I'm 'in service' as people used to say. These girls have a great deal of privilege and very little permitted agency and I'm in the unusual position of being able to witness that first hand. It's a kind of intense, hyper-legitimate girlhood in which they have huge amounts of power and agency as consumers and not much of any other kind.

Like a great deal of people in my sphere of ideas and connections, this year I've been reading Ariana Reines' translation of Tiqqun's *Preliminary Materials* for *a Theory of the Young-Girl*, recently published by Semiotext(e).[1] For those who haven't read it, it's a text originally published in French in 1999 that articulates this new 'Figure' of the Young-Girl; a kind of meaning-form operating in our world, as Christ once did, or Apollo. In Tiqqun's words, from the introduction to the 1999 edition in an anonymous translation, 'The Figure is the "ens realissimum". It is the true metaphysical power. A total category of the social

being, who in the present historical period lends her face to all manifestations of life.' These are only 'preliminary materials' or in Reines' words, a 'diagnosis'. The book is certainly extremely evocative – it's self proclaimed trash theory in the horror mode. The Young-Girl here is the perfect citizen, by which is really meant consumer. I think of the girls I teach, and it's pretty easy to see how that would work. One of them once laughed in my face because I said I didn't feel the need to do a certain job for which I would make lots of money, 'money's not the most important thing in the world' I said. She really thought I was making a joke. 'The Young-Girl would thus be the being that no longer has any intimacy with herself except as a value.' Now, I've seen enough horror movies to know the young girl as monster is nothing new, but for Tiqqun she's a weaponised ur-object in a total war. *Preliminary Materials* is a hyperbolic modelling of a terrifying but all too accurate reading of reality in which the Young-Girl as model citizen of late capitalism is the ultimate axis of coercion and control. We are all Young-Girls now and the text offers almost no way out. There is a sentence on the back cover that I cling to like a raft, 'We propose a different sentimental education'. Those of you waiting for the Chris Kraus angle to kick in probably like the sound of that as much as I do – bear with me!

Not That Kind of (Young) Girl

When you don't know what to do, you look for signs
– Chris Kraus, *Aliens & Anorexia*

In *Aliens & Anorexia* everyone is looking for a way out of an impossible situation. It's 14 years since the original

publication of *Preliminary Materials* and only slightly less than that since the publication of Kraus' *Aliens & Anorexia*. My first instinct after reading *Preliminary Materials* was to reach for Kraus' work. Later I read an article online by someone saying Chris Kraus told her to read it. I can see why, it's nothing if not a call to arms against an enemy she has clearly identified, a coercive, objectified femininity. Both *Aliens & Anorexia* and *I Love Dick* (published just a little earlier, in 1997) work with what we might term girlhoods of one type or another. I've read them over and over because between them they've got both impossible-ways-out and being-a-girl covered and, being a girl, that's come in handy before. Reading Tiqqun has this now not-so-young-girl scared. Before I read it I was freaking out that 'they'd worked out how to blame young girls for capitalism' – I might be paranoid, but then, they might be out to get me. Whether this 'they' is actually Tiqqun or the Figure previously known as The Man is unclear but the effect is scary. Ariana Reines writes that translating the text initially literally made her physically ill but also that she later became able to tolerate it. In an incredible statement written for *Triple Canopy* she concludes, 'I have either overcome something with the help of the others who worked on it with me, or the process of translating it has simply worn me down, beaten me into submission.'[2]

Of course, being partial, what I want to know is what does the Figure of the Young-Girl mean for actual young girls? In some ways I still identify as one and if nothing else I spend a lot of time with them. They may laugh in my face sometimes but I see their lives and I know they've got their own troubles. 'It is not the right to happiness that the Young-Girl is denied, but the right to unhappiness.' In a piece for *Radical Philosophy*, 'She's Just Not That Into You'[3]

which also draws on Reines' account of the translation, Nina Power asks more eloquently than I, 'What, ultimately, would it mean to let the Young-Girl speak for herself and not through the categories imposed upon her by a culture that heralds her as the metaphysical apex of civilization while simultaneously denigrating her?'

Thanks Nina.

So could Kraus' work offer a possible way out of the nightmare posited by Tiqqun? If we're looking for 'a different sentimental education' and are concerned with the rights to unhappiness then *Aliens & Anorexia* and *I Love Dick* seem like pretty good places to start. I think Kraus' work has begun to lay the foundations of what might get us through this. Her radical means of writing the experience of the self allows that experience to be transmitted and assimilated by other selves through reading and vice versa. In these early works these means are put into play with such a transparent performativity that the works function almost like manuals for reading and writing of and through selves. A lot of these selves are girls. There is a vision of a possible fiction that might allow for collective transformation.

Bad girls and Other 'I's

There are a lot of girls in Kraus' texts; all of them were young once.

In *Aliens & Anorexia* Kraus summons the voice of Simone Weil, 'If the "I" is the only thing we truly own we must destroy it, use the "I" to break down "I"'.

In the first few chapters of *Aliens & Anorexia* a particular phrase is repeated, 'Because both of us were girls, Gudrun Scheidecker told me everything about her life.' 'Because

both of us were girls [Colleen] had a talk with me about my problems.' The repetition underlines an ambivalence in Kraus' presentations of actual conversations between women, a sense of disconnect and criticism but also of a constant regret that this is the case. It is in reading and writing that the girls begin to transform themselves and each other, overlapping each other and multiplying via Kraus' autobiography and bibliography. As she says of Ulrike Meinhof, Kraus too is 'willing to think about the distance that separated herself and her young subjects as a subject', the characters from her first film, *Gravity and Grace*, named after Weil's great work, both function on some level as aspects of Chris but there are echoes of Simone too. Gravity, like Weil teaches grammar to adults. She helps them to identify the subject in a sentence. Kraus' many personas have all at some point ceased to be well behaved Young-Girls, and instead they consort with aliens, become terrorists, hags, bad feminists, mystics. They are unprofessional. Women have always had to do away with the Young-Girl to get anything done, but in these early works Kraus, flipping from the first person to the third and – to great effect in *I Love Dick* – the second, nails down the grammar of these transformations. These are what have been described as her radical subjectivities.

Because most 'serious' fiction, still, involves the fullest possible expression of a single person's subjectivity, it's considered crass and amateurish not to 'fictionalize' the supporting cast of characters, changing names and insignificant features of their identities. The 'serious' contemporary hetero-male novel is a thinly veiled Story of Me, voraciously consumptive as all of patriarchy. While the hero/anti-hero explicitly is the author, everybody else is reduced to 'characters'.

It seems to me that that this is a crucial paragraph from *I Love Dick*.

In *Preliminary Materials* Tiqqun present a view of the whole world where this supporting cast of characters is everyone and all these characters are the Young-Girl, citizenship as objecthood, exiled from subjectivity by the total domination of capital and consumption. On the face of it this in some ways doesn't sound so different to what Kraus achieves through the use of first person narrative in these novels, the objectified position of the Young-Girl in both is transformed into a powerful force. 'As the Young-Girl emancipates herself, blossoms and multiplies, the dream turns into an all consuming nightmare' – this line from Tiqqun could be an incredibly negative reading of the potential ramifications of Kraus' early fiction. The difference is that where Tiqqun see us all turned into consuming citizen-objects defined by the character of the Young-Girl, Kraus allows the possibility of a world where everyone, and crucially even physical objects, books or houses, have subjecthood. They are describing the same struggle. Kraus' many I's and subjects are all experts in escaping Tiqqun's 'Youthitude' and 'Feminitude'. 'The Young-Girl punishes no betrayal more severely than that of the Young-Girl who deserts the corps of Young-Girls.' Kraus propagates a method for girls and other objects to articulate their experience by doing so herself. She does so by stating a contingent position, embracing perceived failure, illegitimacy and partial perspectives. In contrast, to an extent, both Tiqqun in their collective anonymity and 'Empire' (Tiqqun's shadowy nemesis, the state, the system, the puppetmaster holding the Young-Girl's strings, the Man) in its omnipotence, function by obscuring or denying position and speaking from nowhere, though for different reasons.

Under capital as described by Tiqqun, 'Empire' is using the Figure of the Young-Girl to achieve total control, Kraus relinquishes the need to be in control, and looks for signs.

Continuing on from the paragraph quoted above, 'When women try to pierce this false conceit by naming names because our "I"s are changing as we meet other "I"s we're called bitches, libellers, pornographers and amateurs. "Why are you so angry?" he said to me.'

The use of the first person narrative functions like a rite of passage allowing the writer to stop being a Young-Girl. Gravity leaves New Zealand and goes to New York and doesn't end up topless dancing because Richard Schechner told her to like Chris did, because Chris did, because Chris got left a box with Simone Weil's book in it by a friend she was kind to, 'keep your front door open to a stranger because the stranger might be Christ.' I get given *I Love Dick* by my first boyfriend and I read about Chris and Gravity and all of them and I know I don't have to be a Young-Girl anymore. Gravity 'remembers how she used to throw her voice around between the hills when she was growing up outside of Palmerston, how it came back to her.'

Whether this can actually work as a means of resistance to the totalising ontology and Empire remains to be seen. I think the experience of Ariana Reines points to the cost of what it takes to test that theory.

I was a young girl and I read *I Love Dick* and I knew I wanted to be bad.

In a way Tiqqun are right when they say 'the Young-Girl is obviously not a gendered concept.' In as much as that it isn't always. Nina Power has brilliantly identified though, that the position of the actually gendered young girl is going to be different in relation to this concept than that of someone without that experience. In a way the only way to

sort it out is to queer the concept of girl, re-defining it as a position of one who has been objectified and must create a position for themselves to become subject. Anyone who has had to do that will be in a different relation to the concept of Tiqqun's Young-Girl to those who have not. There are examples in both *I Love Dick* and *Aliens & Anorexia* of men who do this. I'm thinking particularly of Sylvère's letters to Dick in *I Love Dick*.

How To Read and Write Each Other When Everything Has Been Co-Opted

It seems to me that the solution to the problems raised by Tiqqun's text lie very close to the source. Though Tiqqun themselves state the impossibility of individual resistance to the dominance of the Young-Girl, they also raise 'the question of furnishing arms for a struggle, step-by-step, blow-by-blow, wherever you may find yourself.' Reines, grappling with the text, comes to a kind of powerful understanding and I think Kraus is beginning to provide the sentimental education we need. It's not about self-help (that just creates more Young-Girl war machines). In reading and writing the narrative, the subject multiplies, and the resulting personas are not clones producing endless similar Young-Girls but terrorists who beget hags, who beget lonely girls who beget mystics. It's about access to a lineage of knowledge passed down through crazy, ecstatic and flawed subjects who write to each other across the boundaries of selves. It's about young girls who apprehend the horror of their situation. They read themselves and each other faithfully, out of love and sadness. They've always done it. Without sadness, no empathy. Empathy makes the experience of others available

to us, it's mind altering. Experience can be transmitted. We can communicate with aliens. It's Dick's promise to and then failure to follow through on reading Chris' letters in *I Love Dick* that demonstrates how little he 'gets' what's going on. He fails to understand the power of thinking through emotion and persona, he cannot relinquish control. Witchcraft might be said to be the agency of the powerless. Girls who find themselves young and expected to conform to the images in magazines that Tiqqun mines its ur-picture from, can transform themselves and so the world exactly because, unlike Dick, they have no other choice. They look for signs, open up to chance.

The young girl who laughs in my face when I suggest that money isn't the most important thing in the world five minutes later shyly asks me if I have always been 'quirky'. She pauses before the adjective like she's given it a lot of thought. I wonder if she's looking for a sign or just working out how to beat me into submission.

Footnotes

1 Tiqqun, *Preliminary Materials for a Theory of the Young-Girl*, Ariana Reines (trans.), USA: Semiotext(e) / Interventions Series, 2012.
2 See Ariana Reines, 'Translator's Note to *Preliminary Materials for a Theory of the Young-Girl*', *Triple Canopy*, May 2012, http://canopycanopycanopy.com/contents/preliminary_materials_for_a_theory_of_the_young_girl
3 See Nina Power, 'She's Just Not That Into You', *Radical Philosophy*, RP177, Jan/Feb 2013, http://www.radicalphilosophy.com/web/rp177-shes-just-not-that-into-you

THE ALIEN ANOREXIC AND POST-HUMAN BODIES

SAMIRA ARIADAD

Hunger pains, bearable and lighter than the stomach pains felt by loneliness, being loveless. It's impossible to eat without love. Are these words, these feelings shared, I wonder? Why do I feel so fulfilled by being empty, by withdrawing from an empty world, by withdrawing from being traded?

A few years ago, a Swedish anthology, *Eating Disorded* (2011), was published in which many of the contributions tried to reclaim the agency in disordered eating. What dimensions of eating disorders are missing from diagnostic definitions and public media? Is there space for an analysis which does not focus on an irrational, deranged vision or low self-esteem? The title of my contribution translates as 'The Desire for Anti-Desire'. I tried to both critique and go beyond the idea that anorexia stems from a 'feminine' notion of pleasing others and that it is caused by pressure to conform to contemporary ideals of beauty. Instead I asked what fields of desire we are raised in, what desire and taking up space have come to mean for us, and how people around us have, through their own desire's expansion, ranged violently over our bodies in destructive ways, leaving us in pieces. But self-occupation as a means of change, whether considered active or reactive, is hard not to interpret as narcissistic. That being true, it's difficult to draw the line between internal and external when connections are made in and between both realms. Our relationships are often mediated but also formed in accordance with technological and natural objects in our surroundings, for example communicative machines, and food which is fundamentally social and affective. Yet these objects, while woven with sociality, are simultaneously objectified, controlled and commodified. The question then is perhaps: where does that which can't take place (the feeling of solidarity, the

social aspects of objects) go? These questions meet me in everyday life and in meeting Chris Kraus' *Aliens & Anorexia*, the way I think and talk has changed.

My desire for flight, the urge for withdrawal… a growing desire for starvation manifested itself in the nights when I, the somewhat eating disordered, and my severely anorexic friend melted into the collectives on pro-anorexia (pro-ana) forums. Anonymity made us feel most ourselves sometimes. At that time, I saw a desire for anti-desire present both in me and in other women with eating disorders. This desire, being 'altruistic' (in the sense that it opposes eating for the sake of self-preservation since the pain of the chain of production of goods and relationships is too violent) appears to despise capitalism and the semiotic order, the feeling of things not making sense and the surrounds of waste. Anti-desire, a negation that at least for me means both apathy and oversensitivity, is a strong questioning of individual desire and self-preservation that we for too long have been taught is the natural order of things. But what, in the end, is self-preservation, when the self cannot be preserved or even will its own preservation in isolation, when the causes of strong and secure selves are inescapably social? Actively withdrawing from industry, whether it is the trade of edible goods or sociality based on exploitation, we can ask whether ascetic withdrawal is to be understood as 'self-sacrifice'.

When we don't insist on the division between 'I' and world, altruism seems natural so long as connections on deeper levels exist, so long as demands and visions are incorporated into practices of commonality. The question of this division between self/other, self/world arises in other perspectives on eating disorders, exemplified in the question I've so often been asked: why do you do this to

yourself? A paradoxical question if the definition of illness is something that *afflicts* some people and is not caused or controlled by the disordered themselves. Although the extremes of responsibility and victimhood are represented when talking about mental illness, maybe there is an answer implied in the question itself – the 'I' as non-individual trying to destroy the atomic self created and viewed by others. Is it hard to imagine or believe? Whether treated differently because of intelligence, self-discipline, thinness; or left without anyone to lean on or be understood by, the loss of the sense of home, of safe and relaxed spaces may uncover both our inner splits and fragments and the need for some degree of continuity, meaning and connection.

Humanism and Boundaried Senses of Self

As opposed to feudal inequality, liberal humanism has been one of the strongest political ideologies of equality. The universality of the human (composed of different needs, rights and responsibilities as a citizen in a civil society with the ability to make choices) was a radical idea used in the struggle for equality for several hundred years now, opposing the old order where some humans weren't regarded as such. While humanism and liberalism both to an extent gave us more control and freedom of choice over our bodies by inscribing universality in laws and institutions; the premises of the free subject defined by its soul, cognition and ability to possess and master the body as object, paved the way for the use and abuse of the unity of body and soul. The total self-determinacy of our bodies is but an ideal, our bodies are impossible to master without parts of us being mastered, whether we detach ourselves from our bodies in

self-harm, or try to escape our bodies when they are used and monitored by politicians, employers, partners, parents or doctors.

These ideas and ideals have remained on paper, as most people aren't viewed as autonomous – those with 'disordered' eating being just one example. Collective struggle, rather than empathy of the rulers or even human rights laws, was what gave and continues to give the unprivileged a small chance of self-rule and improved living conditions. I don't think this means we can simply correct humanism, or make it live up to its goals, rather that the post-humanist vision needs to be specific about its political intervention – from the diversity of bodies to common goals, ideas and tools. Who in connection to what objects or subjects and technologies, and which contexts do we want to evolve? Which boundaries are imposed on us from the heritage of free will and limited material reality?

What happens in this clash between prevailing moral judgement based on free will, and the decadent secular society we live in? That is to say, what happens when morals, hard to put your finger on but revealed for example in the guilt and shame of bodily practices, rule at the same time as we are capitalistically encouraged to make selfish decisions and behave decadently where the only recognised value is our market value? Maybe the pro-ana forums can help us again with answers. In the forums, devastating and competitive threads proliferate, but so do a lot of support and understanding – the schizophrenic attachment – until people over time find each other and find trust. As a parenthesis, these forums are banned in several countries and often charge a fee to the forum creator, though some psychologists claim it's a sociality that can eventually help prevent the disease from returning.

If humanism aimed for equality and freedom of choice but in practice excluded women, the poor and the non-white; post-humanism today sketches the same story of the human – utilitarian visions of a rational soul, of a virtual being that can do anything with the help of technology and the will of the soul. The more that women are thought of as owning neither free will nor plastic bodies, the more likely it is their actions will be interpreted through their relationships with their biological selves – not the self she defines but the self others define for her. 'Can't a woman want to step outside her body?' Kraus asks in *Aliens & Anorexia*.

It is only to an extent that affect, as something created in meetings with others, not placed in individual bodies, has come to the foreground of what directs our will and actions; and even then it is most often viewed on an individual psychological level rather than politically and socially. As programmer and literary critic N. Katherine Hayles has argued, post-humanism today has come to mean the full realisation of the disembodied ideal of philosophical history and the liberal (often male) will. The blend of a resistance to the boundaries set by the body and the belief in a disembodied freedom can, even with the best intentions, recreate the same bodily boundaries that were fought against. A good example of this is the definition of anorexia nervosa in the DSM-IV where the anorexic is said to be overly obsessed with his or her bodily form and weight, and have a distorted self-image. The diagnostic definition touches upon the symptom – the manifestation of the bodily focus – and makes focus and sensibility mean a distorted, not simply different, way of relating to and creating reality. It is compared to the 'normal' human and is explained through genetic heritage, beauty ideals or

the relationship to the mother. As Kraus wrote in *Aliens &
Anorexia*:

> No one considers that eating might be more or less than
> what it seems. At best, the anorexic is blocked in an infantile
> struggle to attain a separation from her mother. At worst she
> is passive-aggressively shunning the 'female' state and role. At
> any rate, all these readings deny the possibility of a psychic-
> intellectual equation between a culture's food and the entire
> social order. Anorexia is a malady experienced by girls, and
> it's still impossible to imagine girls moving outside themselves
> and acting through the culture. All these texts are based on the
> belief that a well-adjusted, boundaried sense of self is the only
> worthy female goal.

By withdrawing, the anorexic brings forward the many
paradoxes and clashes of the history of the human as equal,
self-preserving, free-willed and, especially in modern
capitalist and digital society, detached. It is only through
the frames of this human narrative that withdrawal from
basic needs is deemed irrational. The more we sketch the
story of the human as selfish, as altruism meaning self-
sacrifice, the more the empathetic subject is viewed as
flawed and ill, and hence violently corrected into a normal
state of apathy or egoism.

The will to escape being interpreted not as a social and
political being but only ever 'woman', is understandable,
but the path isn't freedom if we think of our desires and
experiences as unrelated to marks made on our bodies and
habits inscribed. What if escaping our bodies or promoting
our right to do so is just a will that coincides with wanting
the same rights and illusions of freedom as the male will has
had historically? What if the problem isn't the fact that we

as women are interpreted as always related to our bodies, but is rather what our bodies are defined as and what they are expected to do? Couldn't a feminist sketch of the self be based on our selves and bodies already being outside, created and creating the outside?

Expanded Bodies

As media theorist Friedrich Kittler wrote, the book can be seen as a prosthetic body, intermediating between the body of the author and the readers. Maybe *Aliens & Anorexia* and other books show, black on white, the complex interplay between non-separable bodies and souls. I've been thinking about reality and fiction ever since as a young child I experienced what might be termed distortions of reality caused by traumatic events – walls moving, nightmares conceived by me as being as real as anything gets. It's not that today I can't differentiate between the feeling that the walls are moving and them actually moving, but the effect that arose and continues to arise in a waking or sleeping state isn't as separable from reality as pathologists seem to assume or wish. The interesting thing about fiction or semi-fictional stories is that they unravel the arbitrariness that lies behind our presuppositions of reality and at the same time draw new patterns and roads fleshy and still flexible as we are. Reading myself through collections of fear and death, mainly by Edgar Allan Poe, didn't only expand freedom of movement for the soul, but, parallel to it, the texts absorbed me into a narrative with resistance to fear and made my body more diverse. Being able to use the academic language often associated with white men showed me both how the academic space isn't reserved

for men, which spaces and tools may be utilised, and at the same time how little space there is for acting outside my structural position of immigrant, woman, and as soon as I arrived in Sweden: working class. The point is that social and political demographic statistics aren't fixed and determined, yet more effort is put today on explaining causalities than changing them. When change is on the map, it is still with the intention to use the knowledge and benefit of 'the others' or technological tools, with no space for experiment. The disparate embodiment of knowledge, visions or lived realities doesn't correspond to the felt limits of humans as discrete units or functional slaves, as many male sci-fi authors or other post-humanist visionaries seem to imply.

How can we point post-humanism in a better direction? What if we turn it around, and try to delimit our thought and draw new maps of the post-human? As N. Katherine Hayles wrote in *How We Became Posthuman*:

> The posthuman does not really mean the end of humanity. It signals instead the end of a certain conception of the human, a conception that may have applied, at best, to that fraction of humanity who had the wealth, power, and leisure to conceptualize themselves as autonomous beings exercising their will through individual agency and choice. What is lethal is not the posthuman as such but the grafting of the posthuman onto a liberal humanist view of the self.[1]

We now know too well, whether we've read Nietzsche or not, the problems with the old moral order, in which western religious morality, especially its priestly agitators, act only to empower themselves while leaving people to direct their wounds of separation and alienation against

themselves. But if we today direct our will to change things against our own bodies, it is not out of ascetic idealism or self-hate, but rather because it's the only framework many of us can operate within. And once within this framework, a vast sense of freedom can be felt, feelings that within the context are neither unrealistic nor deranged. This is to some extent an alternative interpretation of the focus on food and the eating act in general, more specifically in the life of the eating disordered. Instead of reading the will for starvation as questioning the essentiality of self-preservation and the making of food, sex and other desires as primary; this will could reflect how the ideology and philosophy of human needs directs our actions. Several interviews with anorexics show that many experience a lack of power in their lives and are conscious of what they are doing. Whether interpreted as internalised control or actual lack of power and struggle for self-determinacy, the need for control is only shaped in accordance to political power or the lack of it. Without interpreting these internalisations as conformism, space is given for active withdrawal from normal dietary habits and attraction to the extreme, the ugly, whether through embracing starvation or through binge eating. The desire for real sociability, the withdrawal from the individualistic desires that we are all more or less surrounded by and somewhat inhabit, needs to be acknowledged and this process in itself needs to take time.

Difference

Where is the will of breaking out of boundaries created? There are situations where there doesn't seem to be any ambition to break free. This may not be surprising, since

the tangible change of constructed or imagined boundaries is more in the interest of those whose bodies are marked in ways that remove their access to different spaces; people whose bodies have already registered their difference whether they recognise it or not. Bodies that earlier than minds know that we don't own a neutral body and free will – the unprivileged aliens.

Our bodies are changed by our diets, and of course are not only measurable in shape or weight by eating disorderly, but through social withdrawal where they not only become different, but more alienated in the act of starvation. Starvation gives no societal power, no bodily communication that actually reaches out. To an extent, the diagnostic system refigures the disordered within an active role since it describes the anorexic embracing anorexia as a life choice, one which speaks of the alienation and powerlessness felt and expressed by the disordered. A quote from a Swedish psychologist in a major newspaper a couple of years ago explains how anorexics are understood through the value of their personalities: praised for being good girls and patronised because of their perceived lack of self-confidence (which, it is also implied, is unrealistic of them since the outside view of them as good girls should make them happy with themselves/the world). There is no right to define our acts or be understood, the interpretation often speaks over our heads, coming from psychologists or 'feminist' or non-feminist scholars being patronising. This is of course not the whole truth, but there is a need for this philosophical critique of the diagnostic system, and how female acts are interpreted and 'treated' by them.

The anorexic will to control could be interpreted as a demonstration of thought trying to control the body, be stronger than it. In this interpretation, the mind/body split,

if not assumed, is nevertheless a prevailing philosophical ideology that, it is admitted, has effects on our acts. The female anorexic has been understood by some researchers as defying or fleeing her gender entrapment, or outliving the discipline society has taught her is a noble trait. Susan Bordo has written about the tight female body and how achieving it is associated with intelligence and discipline.

The Sociality of Eating

On the one hand, these analyses seem to do exactly what Kraus problematises, that is, interpret women's acts through the way self-image has been formed and through the relationship to the body. On the other hand, I believe that these don't need to be in opposition if we think about them in a nuanced way. The relationship between societal measuring and controlling our own bodies and our own wills and desires that direct our actions isn't causal but does create useful tools. Bordo's analysis of the mirror image as fragmented (we don't relate to our body as a whole but focus on parts of it) paves the way to a more centreless and schizophrenic subject that women to an extent are encouraged to become. By receiving paradoxical and mixed messages, telling us we are free but should never exceed our gender position, we are damned if we do and damned if we don't. Indeed, in many interviews anorexics show great self-awareness of the starved thin body they have created, in contrast with the classic image of an anorexic seeing a fat reflection in the mirror. Whenever the eating disorder is related to the person's view of her body, the focus is on some fleshy body parts. With this fragmented focus and the paradox of control, protest or withdrawal

as independence or flight, another reality and story of the subject is created. The fragmented self-image paves the way for understanding what in humanism is paradoxical: the many wills in one person instead of one identity, controlling and being controlled through bodily extensions, tools and experiments, our inseparability from the surrounding world. Kraus from *Aliens & Anorexia*, 'the origins of food, the social politics of its production. Its presentation. The presence or the absence of true happiness [...] None of these circumstances can be the least alienating in order for food to taste good. Food's a product of the culture and the cynicism of it makes me sick.'

Maybe without the tender touch and smell of the other, without our patience and involvement with it, we either withdraw to isolation or are isolated through mental disorders such as depression, panic or attention disorders caused by over-stimulation. Mechanical meals to fuel bodies that must work and be polished, symbols we either connect to non-related content or let consume and leave behind shells, traces. It's impossible to eat without love. 'There is no beauty because everyone is garbage. Everything is cynically contrived to promote the rapid flow of capital and waste', as Kraus puts it.

When people live to different degrees on the 'surface', and the most valuable things we know are left to chance, we try to create our own causation. If the structural analysis of capitalism (and hence, visions of politically creating something else) isn't in the common embodied consciousness, maybe we need to find meaning or reason in something else, something that brings order to the chaos we can't handle and chaos to the all too predetermined order of material things. A higher power or the free individual. Religion or capital's often prepackaged meanings, freedom

of choice. And when we don't succeed? Can we escape from this, or the subconscious effort to conquer 'the real', which manifests as panic, depression, self-harming behaviour as the diagnoses call it? Could it be that anorexia isn't what I thought it was – a paradoxical situation where the anorexic tries to flee the body but becomes overly obsessed with it – but rather a dis-ease that arises from the confusion of being caught between the contemporary philosophical and political causal narrative of the body and soul? It's about how to escape predeterminism, the mechanical sign of the meal, as Deleuze wrote (also quoted by Kraus).

Kraus describes what's repulsive about food when it has become coins, money, capital. Not that I mean that all abstraction necessarily can or should disappear so we can nostalgically return to the old production of goods instead of commodities, use value instead of exchange value – but the amount of commodities produced for profit and not to satisfy needs or desires has brought with it not only the greed of abundance (for some) but also its antithesis – apathy and appetitelessness.

The paradox of the market is the availability of satisfaction of individual desires and at the same time that marketisation is identity – desires going through the market must be comparable and both presuppose and create the direction of our desires. Individuality is merely an image as we line up for the market. Working on our body is normality, an obsessive normality that makes you wonder – if eating disorders are to be cured in a disordered world, what model of healthiness or normality would we adjust to?

In the words of Rosi Braidotti on Donna Haraway in *Nomadic Subjects:*

If the universal necessitates neutrality, the question then becomes not so much how to think sexual difference positively but rather how to avoid essentialism and biological or psychic determinism in the feminist project to redefine female subjectivity. Haraway invites us instead to think of the community as being built on the basis of a commonly shared foundation of collective figures of speech, or foundational myths. These myths, which are also purposeful tools for intervention in reality, are figurations in that they make an impact on our imagination, but they are also forms of situated knowledge. In other words, feminism is about grounding, it is about foundations and about political myths. It is within this framework that Haraway proposes new figuration for feminist subjectivity: the cyborg. As a hybrid, or body-machine, the cyborg is a connection-making entity, it is a figure of inter-relationality, receptivity, and global communication that deliberately blurs categorical distinctions (human/machine; nature/culture; male/female; Oedipal/non-Oedipal). It is a way of thinking specificity without falling into relativism.[2]

We need the ability to disconnect from the paranoid-narcissistic-self nexus, so as to activate a more affirmative set of passions, enacting simultaneously an act of withdrawal (a minus), and of addition (a plus). Re-interpreted in relation to our context, how can we, aliens not yet communicating, cyborgs surpassing each other, find a common language and practice, not in spite of our differences, but because of them? Can there be spaces for the alliance between the diagnosed and non-diagnosed, which perhaps feel the illness of the world and partly absorb it in their thoughts and bodies? If the obsessiveness of the dietary deviant is about control, how do we create spaces where we don't imagine ourselves in control while expressing our emotions but expand our

expression to the spaces we are in, shaping them and making new ones unbridled by shame, guilt, disconnection and competition? Are we doing it, as we speak?

Footnotes

1 N. Katherine Hayles, *How We Became Posthuman: Virtual Bodies in Cybernetics, Literature, and Informatics*, USA: University of Chicago Press, 1999.
2 Rosi Braidotti, *Nomadic Subjects: Embodiment and Sexual Difference in Contemporary Feminist Theory*, USA: Columbia University Press, 1994.

ON AND ON AND ON: SUSTAINED LOSS AND SYMPTOMS OF KNOWLEDGE IN *WHERE ART BELONGS*

BETH ROSE CAIRD
JESSE DAYAN (ARTIST)

This collaboration began in December of 2012, when Jesse, the artist of the drawings you see here, and co-creator of this project, travelled home alone on a bus to Nyah, his home town some 365 kilometres north of Melbourne, Australia, with a population according to the 2006 Australian census of 323 residents. Nyah is on the banks of the Murray River and was originally founded as the 'Traverner Community Village Settlement' in the early 1890s by a man named Jim Thwaits. It was built upon his dream of becoming a 'utopian socialist self-sustaining community'. This utopian socialist self-sustaining community failed quickly, from lack of access to water for fields and agricultural sustainability, and socialism falling out of favour which led to the end of state support for this community. No common government funding or land handouts were provided. Even by the time the First World War rolled around, the Traverner Community Village Settlement resided as a bizarre and spectacular launch, and then failure of a remote desert town, traversed between the states of Victoria and New South Wales.

It is now a disappearing, socially disadvantaged community on the fringes of the desert and society. The town has a high frequency use of amphetamines, and the neighbouring town Robinvale has become the methamphetamine drug production and distribution town in the state. I had been reading *Where Art Belongs* when I kept promising Jess I would come home with him, drive for six and a half hours and stop at other small towns along the way – but it was Christmas, and we live differently now.

During this period, the complete magnitude of the failed utopia of the Traverner Community Village Settlement dawned upon us, and as the dust settled and the asphyxiating heat and arid land became a kind of final

frontier, we realised that perhaps it is impossible to ever really go home. Jess observed that this place was so isolated, the truck stops like the Malley Region were dry and bereft even of highway prostitutes, and it is impossible to fit a sense of self back into a failed utopia.

Most importantly, we realised that cultural binaries are identity binaries also. Similarly this self-binary works as an autonomous commodity in Kraus' artistic transactions. Kraus has conjoined the personal and fractured stories in *Where Art Belongs* with modern political fictions and philosophy in this unique new self-materiality we see, like endless infinity mirrors bouncing backwards and forwards between Kraus and reader.

Her identification and creation of political fictions and cultural epochs is exemplified in her first hand, or, hand held narration. Perhaps her 'failed' career as a film-maker, or her time working in the sex industry, or her use of self as a material presents the question: what is this

cultish authority in the first person experience? We have two further investigative questions to pose: we aim to examine why Kraus' writing is entrenched occasionally in an expressive presentiment of loss – what is that loss, and where did it come from? And how do deferred knowledge and symptoms of cultural fracturing operate within her work?

During this period it was necessary to turn to the past. To present cultural points of view, or expressions of identifications found in the tenuous voice of Kraus, it's crucial to examine the role of the individual, or self, in relation to art production. Art has come to be understood as a special kind of object motivated by an individual intentionality. Art has existed for centuries as a pivot between the artist and the interpreter; the writer, who views him or herself as a unique voice positioned to make or view, critique or write about artwork. As art historian Amelia Jones puts it, 'this structure is predicated on the idea of art as expressive of a particular, special kind of subjective meaning. Art in this sense is always identified with an individual.'[1]

Identity, like art, is a binary in western thought; the self is always predicated on difference, on the positing of an 'other' who serves to render the uniqueness and superiority of the self. If we can accept this 'self-binary', akin to the unsettling experience of watching oneself eat in a mirror or cry wanking, it can be seen as a way Kraus has achieved such subjectivity, and expressions of freedom, at the expense of an 'other' person or thing. Then we can view her as a self-material author, who uses her representational economy, her commodity, her 'thingness' to write.

In his book, *The One and the Many: Contemporary Collaborative Art in a Global Context*, for example, Grant Kester unpacks the writing of 17th century philosophers

Hugo Grotius and John Locke to situate the being of the
creative artist within an intellectual history of ideas about
individualism. He claims that,

> The 'I' is the foundational site of identity; it possesses the
> body, and the action of the body in the logic of early modern
> thought [...] taken together the body and its actions constitute
> the individual, the only way you can achieve subjectivity, and
> experience freedom, is at the expense of an 'other' person/
> thing, of a lower nature.[2]

It is here the happening, or action of the foundational
sites of literary identity find themselves at a turning
point. Jan Verowoert in *Tell Me What You Want, What You
Really, Really Want* quotes Carol Hanisch on the dynamic
found in the act of witnessing, 'the collective avowal of
collectively unavowed personal feelings that both releases
the individual from isolation and founds the shared reality
of a social course.'[3]

Chris Kraus has brought collectives, exhibitions, bodies of work and dregs of artists from the past into an ever new relation to those throughroads which we use to experience the present. This use of self shifts the significance from the past off the author, into the present.

And what a sense of relief Kraus provides us, what grace. With Kraus present through these critical events, interviewing, living, socialising, the use of self has become a literal artistic tool and even created a range of possibilities in terms of the forms of making and viewing that constitute visuality itself. As both maker but also object of the writing, Kraus' role casts into doubt the inexorability of the gap that normal subjectivity manufactures, and which aesthetic theory traditionally seals into place. Kraus uses herself in order to produce the subject as distinct from the object, and at the same time, manipulates this to entrench their conflation.

One aim of this presentation is to give form to an emotion – to discuss the presentiment of loss apparent in *Where Art Belongs*. This aim was founded in an emotion I feel when I read Kraus' writing. It is understandable however that as this is a matter of emotion, I am doubtful I shall be able to locate it precisely. I am fully aware the task pursued here is potentially quixotic.

However it seems the reason to discuss this loss is apparent: the yearning Elke Krystufek felt in 2006 to travel to Easter Island with her collaborator Donat Orovac could be seen as a symptom of a wider sense of loss, specifically an obsession with disappearance. She had been investigating the haunting disappearance of Bas Jan Ader off his 13-foot sail boat, he had gone missing while trying to sail from Cape Cod to Falmouth in his own artistic pilgrimage. Perhaps the most obvious example of personal and collective

loss in *Where Art Belongs* is the spiralling demise of the Tiny Creatures Collective, the miscommunication and excruciating realisation that a movement, a way of being, exploding with creativity was devoid of longevity. The collection of writing in *Where Art Belongs* positions itself as the afterlife for the artists, collectives and movements Kraus has revealed to us. The second coming as projected by Kraus.

The ghostly re-imagining of the collectives, movements, artists' losses and inconsistencies raises the possibility for us that the deaths in question were not properly experienced when they first happened, and in that sense, they are not over yet. Kraus has identified the artistically undying dead and examines how we might come to live alongside them now. Parallel to this, the inherent sadness within *Where Art Belongs* could be seen as an uncomfortable unveiling of the untimeliness of the events these artists have experienced. Perhaps that very mismatch between event and experience, (experience's endless belatedness) is the historical significance of the events in question.

If this is so, if Kraus has provided us with a regurgitated account of the undying dead artist, then this sense of loss could be read as an unease in witnessing a history yet to happen. And perhaps this is the saddest paradigm found in *Where Art Belongs*.

Witnessing a history yet to happen could be met with the same steady corrosive disappointment of realising a desert socialist utopian settlement is literally drying up in front of you. Or that there comes a point when staring at oneself in infinity mirrors that you cease to be able to see your own face. A history yet to happen. In 1965 Nam June Paik pointed a Sony Porta Pak camera out of a taxicab on the shaky streets of New York City and his face became a framed

image within a framed image. In late 2003 the Abu Ghraib torture and prisoner abuse began by the United States Army together with additional US government agencies in the Baghdad Correctional Facility. These human rights violations in the form of physical, sexual and psychological abuse continued into the new year. In 2003 The Bernadette Corporation completed their video-film *Get Rid of Yourself,* a feature length neo-Godardian interventionist documentary, which took them two years to film, the opening shaky scenes filmed outside the G8 Riots serve as an apocalyptic beginning.

According to Kraus, 'In Spring, or maybe Summer depending on who and when you ask, of 2006, Janet Kim rents out the storefront of 628 N. Alvarado in Echo Park. The immediate neighbours were a bootleg trailer, an ice truck, a vacant lot and a ramshackle house occupied by an old woman who lived alone with her dog.' Friday night, 16 February

2007, Britney Spears takes a razor to her head and shaves her hair off, holding her left hand wrapped around the back of her neck. On the night of 1 November 2008 Natalie Portman is seen leaving a Halloween party in Beverly Hills wearing an action mask, surrounded by paparazzi and does what everyone in the United States does on Halloween – attempts to become another. In 2008, Russian theorist Boris Groys writes an essay on self-design and aesthetic responsibility, using Portman's image of adopting a mask to become real in his text. On 8 February 2008, Kraus finds herself in the 'quiet van' of the 2008 Sex Workers' Art Show driving up 95 North to New York. Writing on the undying dead.

In 2009 Elke Krystufek shows at the Venice Biennale. On the walls she has displayed the words 'Failure, fragility, falling, fatalism'. In 2009 Moyra Davey hangs *32 Photographs from Paris* in an exhibition. And subject can be free from object. And *Where Art Belongs* became a sarcophagus, a gateway to the artistic afterlife. An artistic afterlife. Her literary second coming. This unfinished history is articulated by Roland Barthes in Jean-Michel Rabate's *Writing The Image After Roland Barthes*, 'what I see has been here, in this place which extends between infinity and the subject (operator or spectator); it has been here and immediately separated; it has been absolutely irrefutably present, and yet already deferred.'[4]

By writing for us what is sadly already 'deferred', she shows us the way our own culture now operates by transplanting, disassembling, collapsing and decontextualising things. Here the initial question moves forward: what transcending forms and alternative methods might such an approach to knowledge production, and symptoms of culture being deferred in art suggest? In *privacy + dialect = capital* (2008), writer and independent curator

Clementine Deliss considers a kind of knowledge that actively resists and rejects involvement with conventional modes of knowledge transmission. Such knowledge is highly ephemeral and difficult to control, often circulating covertly and informally among a limited participant-audience versed in the 'dialects' and methodologies that characterise it.

For example, the 'symptom' theorised by Sigmund Freud and George Didi-Huberman as an 'inadvertent non-sign', discusses how artists have made use of non-knowledge or repressed knowledge 'symptomatologically' to expose the limits of the distinction between what is known and unknown and to prompt ceaseless reflections of readings. Or, as mentioned earlier, promote the endless infinity mirrors bouncing backwards between Kraus and reader.

So the unveiled symptomatological limits by Kraus should be acknowledged as an identification of symptoms, which are by definition unintentional and uncontrollable, unproductive and a by-product of something else. Symptoms can be seen as undermining, or at fault for creating a reflexive symptomatology that produces dubious knowledge about knowledge's other, or 'something else'.

To better explain the twists and turns in the equation on symptomatic knowledge in *Where Art Belongs*, one can turn to the then US Secretary of Defence Donald Rumsfeld. In his now infamously rambling epistemological statement about the 'War on Terror' Rumsfeld extends symptomatological knowledge. For full effect I have located the US Department of Defence news briefing on 12 February 2002, where Rumsfeld is quoted saying, 'reports that say that something hasn't happened are always interesting to me, because as we know there are known knowns; there are things we think we know.'

We also know there are known unknowns; that is to say we know there are some things we do not know. But there are also unknown unknowns – the ones we don't know we don't know. The 'unknown knowns' are of course precisely the category that is (symptomatically) absent from Rumsfeld's list.

One could say that practices Kraus has employed articulate the 'unknown knowns' of society. So has she found the ideological unconscious? Have we found repressed knowledge within the pages of *Where Art Belongs*?

Have we found the key to how Kraus defers knowledge to unveil it? Perhaps Kraus has also identified a collection of artists in *Where Art Belongs* who have revealed more about society than they may have realised themselves.

Symptomatological approaches to critical writing and art depend on the aggressively analytical adopted role of the author. Furthering this, they rely on the analytical curatorial role of Kraus in her selection of subject. It is also important to note that any form of critical intentions, warfare, writing, art, performance, all have their own agendas, unconscious, their own unknown knowns.

Further still, isn't it that rather than a 'discovery-objective' approach to knowledge, Kraus is productive, as knowledge occurs within, not outside of herself? So 'self-material' might not necessarily be related to a (male) tradition of object expressive, but rather proposes a radical new method of knowledge and critique. A key foundational symptom of modernism, and its thinking, is the use of dichotomies. It has been argued that their use, and more particularly valorising the male side of any dichotomy, has been a precarious means of underpinning patriarchal thought. Masculinity is equated with independence, science, reason and objectivity. So it is not surprising to see how Kraus has transcended the traditional affiliation with femininity equated with dependence, nature, irrationality and subjectivity through a 'production knowledge' approach.

This method of self-identification is an endless negotiation. Kraus points to the critical gaze itself as reciprocal rather than unilateral in its effects. She is in turn exposed as defining herself and her authoritative tone through the very otherness she attempts to blend away from herself. Reiteration, repetition concludes in performativity. Here discourse produces the effects it names. It is clearly

marked as a site of exchange where the intersections of desire and production serve to flesh out embodied subjects. Ultimately this intersection, this site of identity, is perhaps undermined by an approach to be honest – to be a social documenter in a world where even the most committed theorists of postmodern simulation began to speak about the 'return of the real' as they watched the images of 9/11 on their television screen.

Boris Groys in his essay, 'Self-Design and Aesthetic Responsibility', picked up on this subject to explain the style of honesty:

> We are ready to believe that a crack in the designed surface has taken place, that we are able to see things as they truly are only when the reality behind the façade shows itself to be dramatically worse than we had ever imagined. Confronted with a world of total design, we can only accept a catastrophe, a state of emergency, a violent rupture in the designed surface, as sufficient reason to believe that we are allowed a view of the reality that lies beneath. And of course this reality too must show itself to be a catastrophic one, because we suspect something terrible to be going on behind the design cynical manipulation, political propaganda, hidden intrigues, vested interests, crimes. Following the death of God, the conspiracy theory became the only surviving form of traditional metaphysics as a discourse about the hidden and the invisible. Where we once had nature and God, we now have design and conspiracy theory.[5]

If we can accept these difficult self-binaries, failed utopias, sites of identity, and slippery symptoms of societal knowledge, then we can also come to see how the arresting cultural fracturing found within *Where Art Belongs* happens all the time. Groys calls it 'cynical manipulation' and 'hidden

intrigues', and Kraus has delivered to us the highest of carefully chosen preconfigured unknown knowns. Within these reflective mirrors ricocheting ever upwards back and forth we can come to know this: the fiction of history is to imagine the real. History makes reality desirable. It has the illusion of 'speaking for itself' as if it just simply 'happened'. These stories Kraus has identified condense time the way maps miniaturise space. But somehow, condensing time seems to distance the past from us rather than bring it closer. What Kraus has done to us is unfold a story – what really happens in a story is language.

In January of 2013 I am down at my beach house reading everything Kraus has ever written to prepare myself for this piece. There is a freak storm of gale force winds coming straight in off the Bass Strait, that is, straight up from Antarctica and I cannot contact Jesse via mobile phone, still

in Nyah for a week. I become agitated and unsettled at the unusual ferocity of the weather and the anxiety of writing in a place that is to me, filled with just your average your run of the mill, dead-end town, dying-community sense of loss. It is not hot, but I cannot sleep. When I see Jesse he tells me that his father had told him of a station farmer, an acquaintance of the family who had needed a new working station cattle dog.

These farmers, on their stations, often run massive properties in the desert over 100,000 acres which run mostly cattle, and require at least 6-10 aggressive working dogs to control the cattle and work the station. These stations run massive herds of cattle, the land too arid to grow crops off. Independent kangaroo shooters come to stay to hunt at night. So that the station owner could leave his truck unlocked in small towns, the farmer needed a way to ensure indigenous Australians didn't try to steal from his truck. Jesse told me that station owners had come up with a way to make young puppy working dogs 'hate', or only attack Australian indigenous people. To make a dog hate an indigenous person, the farmer would place the puppy in a garbage bag, tie it up, take the puppy in the bag to a drunk and high indigenous person and offer them a six pack of beer to kick the shit out of the garbage bag for five minutes and then rip open the bag so that the first thing the puppy sees is an indigenous face. This way, after numerous kickings, the dog will ferociously and violently guard the truck when an indigenous man approaches. Kraus has given us a way to see ourselves, an endless reflection of our own Nation, our own cultural practice, through these inadvertent non-signs. The unknown knowns.

There are cultural fractures everywhere. There are crossroads of desire and identity every way we turn. And

there is such profound loss – stories of loss – which are happenings of loss. Failure, fragility, falling, fatalism. If we can take anything from the complex unknown knowns, from what Kraus has done to us, it is this: the unknown is more than a chance at endless mirroring possibilities, it is a provocation that propels us on a journey, a route of unknowing, in which we experience many of the ways that we do not know something, both when we are speaking in terms of sites of identity, en masse, or simply when transacting with each other as individuals, and through scenes of profound cultural loss – well I think there is solace in that.

Footnotes

1 Amelia Jones, *Seeing Differently: A History and Theory of Identification and the Visual Arts*, UK: Routledge, 2012.

2 Grant Kester, *The One and the Many: Contemporary Collaborative Art in a Global Context*, Durham, NC: Duke University Press, 2011.

3 Jan Verowoert, *Tell Me What You Want, What You Really, Really Want*, Vanessa Ohlraun (ed.), Berlin/New York: Sternberg Press, 2010.

4 Jean-Michel Rabate, *Writing the Image After Roland Barthes*, USA: University of Pennsylvania Press, 1997.

5 See Boris Groys, 'Self-Design and Aesthetic Responsibility', *e-flux*, journal #7, June 2009, http://www.e-flux.com/journal/self-design-and-aesthetic-responsibility/

SPEAKING CANDOUR

KAROLIN MEUNIER

This sentence may function as a hook line:

BECAUSE THEY WERE LISTENING TO EACH OTHER HARD, THE ROOM SEEMED SMALL.

Quote from Chris Kraus, 'Emotional Technologies', 2000

In her novels and art critical essays Chris Kraus expressly makes the realm of her own experiences the starting point of both fictional stories and theoretical reflections. In the opening statement of 'Stick to the Facts', a short text published in 2008, Kraus describes her principle of always aiming for intensity and immersion when encountering a text, 'The best writing achieves intimacy, draws you into the mind of the person who wrote it, brings you out of yourself and makes you believe at least while you're reading that something is happening.' Intimacy here seems like a means of establishing a substantial connection between reader and writer and less like a mere indication of

the sincerity of its author. 'It has always struck me strange,' the text continues, 'when people approvingly describe my art writing as "honest" and "personal". What else can it be? Writing narrates experience.' Kraus challenges not only the border between the different genres, fiction and criticism, but instrumentalises the act of self-disclosure for her own ends. Not excluding sexuality and the experience of failure from her self-descriptions (and those of her female protagonists) as well as inserting autobiographical facts, many of her texts sound like revelations. However they are characterised by the use of stylistic devices which undoubtedly dispel identification, e.g. alternating between first and third person within the same text. The question of how much truth or biographical reality such revelations contain becomes peripheral. Despite Kraus' proclaimed affirmation of the personal and a literature that draws the reader 'into the mind' of another person, her writing is a counter-model to the concept of a simple confessional output. A distinction she makes very clear in 'Stick to the Facts':

> There is a recurring tradition of candor in Western literature [...] 'Candor' should not be mistaken for 'confession'. While confession pursues its cheaply cathartic agenda (will everything 'change' once the confession is made? Doubtful...), candor is essentially disinterested. Candor is a willingness to speak to the present with a certain presence, or as the poet Lew Welch described it, the exact transmission of mind into word.

What Kraus seems to draw our attention to are the different intentions involved in truth telling and how a particular contextualisation of such speech acts changes its effect on both writer and reader.

But why am I interested? In fact, I wouldn't want people entering my mind, and I'm surprised when others are willing to open up theirs. But then, apparently, I like to be drawn into someone else's mind, at least for a while, to borrow some of their experiences. I have never been a table dancer. And, more generally speaking, it is also about the way in which people decide to present themselves publicly, and the range of options available for such presentations. It is so common for people to disclose information about themselves and their actions, and it seems to be performed as a matter of course. My interest is in the model of writing and talking about oneself as a means of abstracting one's own experience. Who or what triggers such speech, and how can one choose it as a form? Is it possible to rehearse confession and become better at producing truths? The transitions from hidden to public, from thinking to speaking, from internal to external dialogue produce interruptions whose extension, formalisation and exaggeration (in literature) I would interpret as techniques that highlight the constructed nature of such self-disclosures, as well as the difference in position between speaker and listener. Another artist who works extensively with autobiographical material made a similar statement as Kraus. In the prologue to her 2006 memoirs *Feelings Are Facts: A Life* Yvonne Rainer describes not only what compelled her to write and publish her memoirs, but also her misgivings about the confessional genre,

> Do I wish to make claims to a hearing and in so doing seek 'a catharsis of confession'? In our talk-show saturated culture 'without confessional talk we simply don't exist'. No, I must remind myself that my existence does not depend on some kind of secular redemption through self-exposure.[1]

OK, I got it: no to confession, no to catharsis. However, while both authors deny the cathartic aspect, their artistic practices nonetheless claim an interest in talking about oneself as performative act, and in the personal as material to be consciously deployed. These forms of speech still partake in 'truth production', and I am not sure if one can so easily escape the trap of confession.

Karolin Meunier, *Timing and Consistency*, video still, 2010

The term itself is associated with certain specific speaking situations such as the confession of legal guilt, the religious confessional, as well as psychoanalysis, which take place at such diverse locations as courts, hospitals, churches, the internet and TV studios. But 'confession' also evokes more general moral ideas of sincerity, unfeignedness, truth and guilt. Michel Foucault investigated confession and its history epistemologically, 'Next to the testing rituals,' he wrote in *The History of Sexuality* (1976), 'next to the learned methods of observation and demonstration, the confession became one of the West's most highly valued techniques

for producing truth.'[2] His interest primarily regards its control function within specific power relations. In the discourse of sexuality he finds the twisting of the relation between censorship and coerced speech that characterises confession. The 'internal ruse', he said, lies in seducing the confessing subject into speaking, through the appearance of confession itself as a defiant refusal of a prohibition to speak, a prohibition from which one must free oneself. An effect of this ruse is the belief that a decision in favour of honest speech is an expression of freedom, when in fact it has long been an internalised command. As a ritual this activity thrives on repetition; the impulse to overcome the resistance to self-narration becomes habitual, and the power relation within which this happens loses its contours in the course of the routine. In this sense it would not matter whether the occasion for this speech appears as a need, an invitation or an act of enforcement, or as one of these things dressed up as another: in confession a format is being used, subject to certain limitations determined by its occasion and setting. These limitations correspond to the promise of a result, to the effect of healing, attention, absolution. It may be regarded as a manifest structure but, at best, also as an instrument to put to use, precisely because of its cultural and historical overdetermination, its exaggerated focus on results and effects and its complicity with institutions.

The position of both Kraus and Rainer can be read as critical of a concept of confession that limits it to an instrument of control. And indeed, not every self-description is written in stone. One is not ordained to be disciplined by the confession. One is not at its mercy. When a person talks about themselves, the circumstances and intentions do make a difference, changing the text and the personal risk and position of the speaker. Kraus' distinction

between candour and confession seems helpful here (though I would say they are intertwined, part of each other). When Kraus describes candour as willingness 'to speak to the present with a certain presence', it is assigned a more active role. But why is it disinterested as Kraus proposes, if, on the other hand, writing and reading should provoke intimacy and presence, and something is happening? As an alternative to the confessional model candour is no less performative, but it may work against the identifying moment of admission, preferring the disidentifying force of forthright speaking out as well as to set a story in motion by telling and sharing it and not pinning it down to one person and their feeling of guilt. Kraus concludes by saying, 'Despite the utter debasement of all things "personal" through the rise of therapeutical/confessional culture, what the world needs is more presence, not less.' Hers is an approach, which instead of claiming that secret keeping, concealment and obfuscation are expressions of freedom or subversive acts, gives short shrift to the cathartic function of avowal exactly from the margins of the autobiographical format. But candour, the quality of being open and honest in expression, is not an easy task. To me it would seem more suitable to immediately try to get away from one's own candid words and their tendency to produce all-too-definite narratives and identities. The feeling of distance that opens up to one's own experiences perhaps explains the sense of unease that accompanies this speech. It is hard work to speak freely. At the same time there is the desire to experiment with the possibility to observe and describe oneself. Even Foucault's description of the potential of such speech to be deployed strategically as well as to get out of control sounds less like a mere root cause analysis of internalised control mechanisms and

more like a description of the motivation for conducting a self-experiment. He wrote of 'the invention of pleasure in the truth of pleasure', the 'pleasure of knowing that truth, of discovering and exposing it, the fascination of seeing and telling it, of captivating and capturing others with it, of confiding it in secret, of luring it out into the open.' In the sexual confession he refers to and in confessional language more broadly, truth becomes a contentious field, where exhibiting and concealing alternate with and determine one another.

YouTube Blank Template 2.0, The Casey813, 2010
http://caseygray.webs.com/apps/photos/photo?photoid=85580904

I think it is precisely this moment of 'pleasure in the truth of pleasure', and the risk and excitement of telling it that connects the idea of self-disclosure as a cultural technique with a recurring motive in Kraus' work: that is a performative, or conceptual, perspective on sexuality especially on sadomasochistic practices and the fascination of a social interaction determined by rules. In 'Emotional

Technologies', republished in *Video Green: Los Angeles Art and The Triumph of Nothingness*, she writes about the everyday life and work experiences of an artist and art critic, whose perspective could be that of Kraus herself. She links up observations of the art scene in Los Angeles with her, or her female protagonist's, excursion into S/m dating, and with the techniques of Polish experimental theatre director Jerzy Grotowski in the 1960s, whose exercises, she writes,

> aimed at pushing actors into states of pure intensity [...] There is no experimental theatre in sadomasochism. That's why I like it. Character is completely preordained and circumscribed. You're only top or bottom. There isn't any room for innovation in these roles. It's a bit like what Ezra Pound imagined the Noh drama of Japan to be, a paradox in which originality is attained only through compliance with tradition. Tonalities and gestures are completely set, and so exactitude is freedom.

In the same text Kraus refers to Foucault's late writings on the 'Technologies of the Self' and mentions that according to a number of interviews he played S/m himself. What she proposes is an analogy between the idea of 'technique' in sexual practices and as an aesthetic principle in order to dissolve the opposition of technique/rules vs. originality/ innovation: e.g. the systematic work of constructing a text while reconstructing one's own experiences. 'Because they were listening to each other hard, the room seemed small', a quote from 'Emotional Technologies' describing the tension between the woman in the story and her Dom partner, could equally illustrate the relation between a performer and their audience.

The expectation that sexuality and artistic work, as well as talking about these things, will involve authenticity, is

suspended if specific rules are followed. To accept clearly defined roles as specifications for one's own behaviour, for movements and speech acts, might establish a distance from familiar patterns of activity. These, however, neither throw into question the intensity of what is experienced, nor do they cancel out its performative effect – even invented or stylised self-disclosure can provoke relief and shame, or conversely the sensation of self-empowerment and rebellion. The counter-project staged by Kraus, in which subjectivity is dissolved by the fixed roles of sadomasochistic practices in order to eliminate the obligation to experiment and innovate, is certainly a thought-play as extreme as it is bold. In Kraus' latest novel, *Summer of Hate*, the female protagonist, Catt, makes a comment on the same topic: 'Besides, she'd already reported on these experiences in her last book of essays, juxtaposing the extreme, nuanced presence of BDSM games with the blankness of academic neo-conceptual art. These faux-naïve arguments shocked most of the art world but received knowing laughs from her fans.'

And yet this example really does show the ambivalent relationship between, on one hand, sheer exposedness to a situation controlled from outside, and on the other, the intent to create an experience of exposure to control. It could be argued that there is indeed an experimental approach in the decision to act according to fixed rules for a certain amount of time, still more so when the decision is made from an aesthetic and self-reflexive perspective. It remains an experiment because the scene entered into remains bound to an individual and his or her specific context. But the more rigid the rules, the more minimal the possibilities for variation, making self-observation easier. The less one seems to appear in what one does – the smaller

the stakes – the greater the risk of delivering oneself to something overwhelming. More is expressed here than a merely instinctive obedience to prevailing standards and expectations. The exclusion of subjective, contingent gestures bespeaks a need – or amounts to an attempt – to disrupt those gestures' hidden correlation to certain norms. To submit to extreme rules can also be an expression of withdrawing from the false option of a free speech.

Essentially, the question concealed is how to trick the truce, how the imperative to produce a discourse about oneself can be appropriated deceptively and the technique be revoked and rededicated. If a certain awareness of the constructed and manipulated nature of confessional or honest speech is assumed to be present in autobiography, interview, etc. as forms of expression, then the attributes of construction and manipulation function as a sort of hinge for whatever intentions are involved. The transfer of what has been experienced – which on one hand entails the outward projection of interiority through speech, and on the other the act of bringing oneself into the game – may be impossible as an immediate gesture. As a technique, however, it can be strategically deployed in order to meet the demands of both public and private summons to self-reflection, or indeed to rid oneself of them. The truth created in this process would always be the truth of the situation. The concept of 'being present' in what one says or writes sets the focus on the reciprocal dynamic between artistic-literary practice and personal engagement: how the personal changes as soon as it becomes narrated in public, and what happens when, conversely, one begins to understand it as an experimental set-up, organising it according to certain criteria. The insistence on the meaning of the private and everyday as narrative – particularly as a feminist concern – has

always also been a political instrument: to cultivate public speaking about one's own experiences and circumstances as a situation, to learn this, to propagate it, to see it as an opportunity to develop a distinct vocabulary, and, in Kraus' case, using the autobiographical as a strategy to analyse certain social conditions and, not least, claiming a territory when writing about sexuality as well as working conditions, as a woman.

I am tempted to overstress the picture of a kind of listening that makes the room small as an interesting concept of listening. If what one says could even sound formulaic it doesn't necessarily require a judgmental, nor even understanding, form of listening but rather the simple acknowledgment of being in the same space.

Footnotes

1 Yvonne Rainer, *Feelings Are Facts: A Life*, USA: The MIT Press, 2006.
2 Michel Foucault, *The History of Sexuality, Vol. 1: An Introduction*, USA: Vintage, 1978.

AGAINST CRITICAL DISTANCE: DISTANCE: CHRIS KRAUS AND THE EMPATHETIC EXCHANGE OF OBJECTS

LINDA STUPART

I often fight with Speculative Realist boys. This is unsurprising, considering their desire for a non-political, non-aesthetic flat ontology, their recurring assertion that a feminist critique of their Object Oriented Ontology (OH! OH! OH!) would be 'ridiculous', since it would be human centred, individualistic even. That O O O has nothing to do with gender phenology or materialism or objectification, except to the extent that O O O suggests that everything is an object and therefore adheres to the laws governing objects: an adherence to a flat ontology, which does not allow for dominance.

However, there is something other than their clean-shaven neat white boy sexiness that draws me to the Speculative boys' objecthood: firstly, I am sympathetic to a call now in time of environmental and every other kind of crisis for a non-anthropocentric conception of being.

But, more than this, I am drawn inexorably to the possibility that the subject is not the only emancipatory proposition: the possibility for becoming a thing that feels, and thus for a new exchange between things. Things; a set that includes both people and art objects.

Becoming Object

In her essay 'A Thing Like You and Me', Hito Steyerl writes, 'But as the struggle to become a subject became mired in its own contradictions, a different possibility emerged. How about siding with the object for a change? Why not affirm it? Why not be a thing? An object without a subject? A thing among other things?'[1]

So, as Steyerl suggests, instead of aiming for subjectivity, which is anyway to be subjected to an other, instead of trying

to get back, behind and before the image, to some imagined and originary subject, what if we could become objects, be things? What new possibilities might this produce in the exchange of materials, commodities, but also specifically in exchanges with art objects?

In Mario Perniola's *Sex Appeal of the Inorganic,*[2] the author writes:

> To give oneself as a thing that feels and to take a thing that feels is the new experience that asserts itself today on contemporary feeling, a radical and extreme experience that has its cornerstone in the encounter between philosophy and sexuality [...] It would seem that things and the senses are no longer in conflict with one another but have struck an alliance thanks to which the most detached abstraction and the most unrestrained excitement are almost inseparable and are often indistinguishable. The lover who gives himself[3] as thing has the impression of subverting a tradition that saw him as living, desiring, pleasure-loving, moved now by animal, now by spiritual drives. At the same time this subversion allows him to include the neuter of sexuality, completing the movement of libidinal appropriation of the opposites that led Sade and Masoch to sexualise fear and pain. It is as if philosophy and sexuality found in each other what was necessary to accomplish their own historical journey. In the experience of becoming extraneous clothing meets the speculative suspension of libido and the sex appeal of philosophy.

In her 2000 essay 'Emotional Technologies', Kraus writes:

> I've been kneeling here about ten minutes in the sheer black blouse, the crotchless panties. I don't dare get up long enough to check my makeup. My back is straight, my palms and cunt

are trembly. The motion sensor-light outside the house blinks on and then the door swings open. My eyes are lowered like he told me, looking only at the black jean legs below his waist. He shuts the door... 'My body is yours. You can do what you want with it.' I'm speaking in a voice I've never used before.

Against Critical Distance

In *Postmodernism: Or the Cultural Logic of Late Capitalism*, Fredric Jameson tells us that 'modernist cultural politics, all shared a single, fundamentally spatial, presupposition, which may be resumed in the [...] formula of critical distance.' But in the (then) current cultural era, Jameson argues, 'distance in general (including critical distance in particular) has been abolished in the new space of postmodernism. We are submerged in its henceforth filled and suffused volumes to the point where our postmodern bodies are bereft of spatial coordinates...'[4]

Critical distance, then, predicates the absolute autonomy of the work of art, as well as describing the necessary objectivity of the critic. Or, since the terrain of the object and the objective is at the uncertain and shifting core of this paper rather that which is often named as objectivity – that is a lack-of-history, of specificity, persona, a lack of emotion, a lack of particular personhood a lack of baggage, angst, an absence of anything internal or present in the critic that could exist outside of the no less particular, reasoned and cerebral relationship between art object and critic.

This relationship, however calm and distant (Clement Greenberg stands with his hands behind his back, leaning in towards an abstract painting, but they never touch) is also one predicated on the hysteric/analyst relation: the

modernist artwork speaks in all its alleged autonomous complexity, its multiplicity; in tongues. And the Critic fairly, reasonably, looks and listens carefully and decides whether she is truthful or good or important or avant-garde, and dutifully translates her texts into linear readable case studies, which are then shown to everyone – as both critique of the work, the patient, the object; but also as rule, as *taste*.

Though Jameson may have heralded the collapse of critical distance 20 years ago, and while new forms of criticism, art writing and so on are currently furiously taking hold, breeding maggot-like in the still warm bodies of criticality, there remains in institutions and art schools everywhere the debilitating hangover of modernity within criticism. How many times am (even) I told that as a critic my role is to translate or to explain or to tell the reader something of the transcendent quality of an art object/event, which they themselves may not see, may not 'get', *but I can*: something entirely unrelated, of course, to any feeling outside of an immediate relationship with said object. Critical distance, with its elitism, emptiness, its macho genius and boring contingency, is still clinging to art and art worlds, reborn as zombie in the indeterminate emptiness of post-postmodernity or contemporary art.

Privilege

Before it is judgement, or clarity, unemotionalness, clear-headed apoliticalness, Critical Distance is first of all predicated on a privileged subject/object divide: the ethical aesthetic object/art event is to-be-contemplated by an active gazing subject/critic.

The critic has authority over the object and remains safe in a clear divide between speaking/writing self and silent, or else hysterical, other.

After an artist's talk I asked him, 'Hey, so you wanna be an object? You wanna be a corpse?'

'Because I've been dead twice. And other things – tied up, fucked up, still on floors, stationary. If, you want to talk about becoming an object, being a corpse, maybe you should have asked someone who is/who was/who has been (dead).'

Objectification

Of course, this relationship between he who looks and speaks and that which is looked at, is familiar as the grounding principle of sexual objectification, certainly as it is laid out in foundational texts, the becoming-thing against which much of the feminist project has, rightfully, fought.

In 'Visual Pleasure and Narrative Cinema' Laura Mulvey speaks at length about the manner in which women become a particular type of object – an image – produced by and for a masculine economy where:

> In a world ordered by sexual imbalance, pleasure in looking has been split between active/male and passive/female. The determining male gaze projects its fantasy onto the female figure, which is styled accordingly. In their traditional exhibitionist role women are simultaneously looked at and displayed, with their appearance coded for strong visual and erotic impact so that they can be said to connote to-be-looked-at-ness.[5]

When I looked at the artist, photographed him, red shoes, gazing downward, not returning the gaze, when I listen to his voice over and over speaking about death and sex and representation, masturbating as I would thinking about any other skinny art boy – he perhaps becomes closer to the corpse they all want to be. For many of *us*, for women, including women artists, writers, philosophers, we are already much closer, even, to the object-corpse so popular with those Speculative Realists.

People often ask me about this scar on my chest.

Usually I will respond in one of two ways:

'Well, you know that scene in *Indiana Jones* where the bad guy rips out that other guy's heart from his chest? (It's just before he pushes him into the pit to sacrifice him and then holds the heart in his hand still beating...)'

This explication is necessarily accompanied by a demonstrative hand movement: fingers bent at top and middle joint curl up from flattened hand and bend, pause, bend, pause; squeezing invisible meat.

Well, it was like that.

Or:

'So, I was dead for six hours. And now I'm not. Basically, I'm a zombie.'

Since the zombie seems to have become the dominant metaphor for the object-oriented subject of 'Late Capitalism' I tend to favour this explanation, particularly when speaking to those cute, white, young Speculative Realist boys.

I find that it excites them suitably, my animated corpse.

This, surely, though, is not the only fun that I, that we, that can have with being dead? The only constitutive possibility for an already-objectified feminine?

Does not this recognition of objecthood, this desubjugated, but not unfeeling position seem the best

place from which we might talk to other objects? Ethical aesthetic objects like us, or, to go back to Hito Steyerl: A Thing Like You and Me?

Body

In Irit Rogoff's 'Smuggling' she writes of a post-critical possibility, an 'embodied criticality':

> The notion of an 'embodied criticality' has much to do with my understanding of our shift away from critique and towards criticality, a shift that I would argue is essential for the actualisation of contemporary cultural practices. Briefly, this is a shift away from a model that says that the manifest of culture must yield up some latent values and intentions through endless processes of investigation and uncovering. Using literary and other texts, images and other forms of artistic practice, Critical Analysis attempts to turn the latent of hidden conditions and unacknowledged desires and power relations into a cultural manifest. Using the vast range of structuralist, post and post post-structuralist tools and models of analysis we have at our disposal, we have been able to unveil, unravel, expose and lay bare the hidden meanings of cultural circulation and the overt and covert interests that these serve. But there is a serious problem here, as there is an assumption that meaning is immanent, that it is always already there and precedes its uncovering.

Rogoff suggests a move away from popular cultural/ curatorial criticism, which she claims,

is a form of finding fault and of exercising judgement according to a consensus of values, to critique which is examining the underlying assumptions that might allow something to appear as a convincing logic, to criticality, which is operating from an uncertain ground of actual embededness. By this I mean that criticality while building on critique wants nevertheless to inhabit culture in a relation other than one of critical analysis; other than one of illuminating flaws, locating elisions, allocating blames...[6]

Thus, Rogoff privileges a grounding, which stands in stark opposition to the indeterminacy, apoliticism, genderless arena of contemporary art. This grounding is an integral step in the production of the art writer as object, a proposition that extends Rogoff's beyond criticality to empathy, via, in part, embodiment.

We could go all the way back to phenomenology (a useful detour perhaps) to talk about the body-as-object, or to corporeal feminism, the pre-post human. We are all bodies, however, often the contemporary body that is a chain of systems of affect, inscription, memory, sometimes seems to escape the thingness of bodies, their objectivity; our meat envelopes.

Chris Kraus' object-body is doggedly present in all her work, however, and particularly her earlier books: the starving body in *Aliens & Anorexia*, the devastated body, sick with Crohn's Disease in *I Love Dick*, the cunt in crotchless panties in *Video Green...*

Kraus gives blowjobs in bathrooms, is tied up, is vomiting, falling. Even as she tries to leave the body in *Aliens*, we are constantly reminded of the author's corporeal objecthood, her feeling thingness...

Materialism

It is not just her physical body that Kraus treats as object in her work, but also her personhood, biography, history – her 'I', which is picked up, turned inside out, handled, looked at from outside and inside. The main character of *I Love Dick*, Chris Kraus, slips into an abject, debasing 'I' that seems intent on destroying itself.

In *Where Art Belongs*, Kraus comments on contemporary art institutions, 'The artist's own biography doesn't matter much at all. What life? The blanker the better. The life experience of the artist, if channelled into the artwork, can only impede art's neo-corporate, neo-conceptual purpose. It is the biography of the institution that we want to read.'

Kraus' work, however, consistently resists this affected absence of history, experience, life – resists what is an ironic re-appearance, within the ungroundedness of contemporary art, of modernity's imperative of critical distance.

Kraus' life, her personhood, is material, her self becomes object, and this transfiguration is all the more convincing in that she does not treat herself carefully, gently, rather she writes herself as complicit in her own materialism, in history. She participates in her thingness through pulling herself apart, becoming old object.

Because a thing is usually not a shiny new Boeing taking off on its virgin flight. Rather, it might be its wreck, painstakingly pieced together from scrap inside a hangar after its unexpected nosedive into catastrophe. A thing is the ruin of a house in Gaza. A film reel lost or destroyed in civil war. A female body tied up with ropes, fixed in obscene positions.[7]

Empathy

'The panic of altruism', Kraus writes in *Aliens & Anorexia*, '[...] sadness rests inside the body, always, nascent like the inflammation of a chronic disease. Therefore, empathy is not a reaching outward. It is a loop because there isn't any separation any more between what you are and what you see.'

Empathy, then, should not be considered as a feeling for, or as compassionate towards. The empathetic exchange between objects is not the opposite of criticism, it is not necessarily *nice*. Rather it performs a radical act of voiding distance, of finally undoing the privilege of the critic, a new act of speaking that collapses the border integrity, the separateness, the empty, masculine genius of the critical.

It is a constitutive erasure and a re-institution of ground.

In 'Deep Chaos', an essay about artists Christiana Glidden and Julie Becker in *Video Green*, Kraus writes of the art school in which she teaches, 'While the word 'personal' is generally used as a pejorative, multiple subjectivities – the knack of being everywhere and therefore nowhere in particular – are seen to be a very good thing.'

'I am caught up in the haze of midsummer Los Angeles', she writes in 'Emotional Technologies', 'the cosmetic edge we give to its preemptive emptiness.'

Kraus continues in this essay to describe the elements of the artists' installations, which it is clear that she sees because of their particular relation to her own materiality, her history, her objecthood. She talks about whether frogs are more like penises or vaginas, she feels fearful... She is deep inside the artists' installations – feeling them, as they feel her – a collapse of border integrity.

Towards the end of the piece, Kraus conjures Paul Thek's *Death of a Hippie* (1967), his becoming-corpse object. In *Aliens & Anorexia*, Kraus writes of Thek, 'Thek, who was ambivalently homosexual, was arguing for a state of decreation, a plateau at which a person might with all their will and consciousness, become a thing.'

This Association

In the summer of 2012 I took a much easier route to becoming a thing, in an attempt to position myself better to write about what I knew would be considered a 'game changing' work of art. This artwork was *These Associations*, a work by Tino Sehgal. The piece was the final in the Unilever series' Turbine Hall Commissions. I worked, officially, as was written on my contract, as a 'participant' in the piece from when it started in July and ended 28 October 2012. We got paid £8.33/hr (then known as 'London living wage') and worked either four or eight hour shifts.

The job required us, essentially, to do a lot of running up and down the Turbine Hall, forming patterns according to a complex set of inter-participant rules and interactions, to sing, sometimes, and at any moment during the piece, to walk up to any of the Tate visitors and talk to them in manner also guided by a set of themes, rules:

Arrival
Belonging
Satisfaction
Dissatisfaction
A quality in a person that you admire (the quality, not necessarily the person)
To be overwhelmed

These should be tellings of true stories from your own life, to be told in the first person. They should elicit empathetic rapport and generate affect. In depth emotional conversation with visitors is encouraged as long as it remains on theme.

The great thing about this kind of participatory practice is that as participant, as the work's material, you (or in this case I) are already art objects, already able to engage in an empathetic exchange, perhaps, without an outside to the art-thing. That Sehgal was using not only our bodies, but also our histories, our first persons, our 'I's made this transformation to object seem all the more complete.

On 9 October 2012, while we were running around, the Tate's alarm went off. Sehgal decided that we could continue the work outside of the gallery's architecture: we could create rapport, run, ache, outside. Revolting, however, I took the opportunity to smoke a cigarette.

Descha, who is middle management on the piece, is standing next to me. He lights my cigarette and I look at him in a way that is meant to tell him that I both simultaneously and absolutely hate and also love him.

The alarm going off today has a particular shrill weight since the previous day a man entered the Tate and 'defaced' a Rothko, signing it; a crime for which he will spend two years in jail.

We start to talk about the Rothko – about how it feels. This is not an anthropomorphising of the painting, nor a comment on its transcendence – I do not suggest that the maroon is sad. However, I wonder how the canvas felt the pen, the dried paint the pressure of nib, the frame strained under a slight new pressure...

I then start a conversation about how, were I to deface something it would be Carl Andre's bricks – how I would

pour blood all over them, how I would remind people about Ana Mendieta about how fucking terrible, sexist, awful, absolutely horrendous and misogynist the art world is, how he got away with fucking murder how... I pause midway through this rant, to look at Descha, his girlfriend, who he loves and who I have not been able to look in the eye up until now, even though one of the sequences in *These Associations* requires us to meet each others' eyes. Because, of course, I slept with him, he fucked me, we tried to wrest ourselves from the structures we were running, he left me, he came back with her.

'Hi. My name's Linda,' I said.

I was, to quote Kraus, in an essay in *Video Green*, 'The Blessed', 'a stationary object teetering without a station.' And the Rothko continues to be mended, repaired...

Footnotes

1 See Hito Steyerl, 'A Thing Like You and Me', *e-flux*, journal #15, April 2010, http://www.e-flux.com/journal/a-thing-like-you-and-me/

2 Mario Perniola, *The Sex Appeal of the Inorganic*, New York/London: Continuum, 2007.

3 Although I find *The Sex Appeal of the Inorganic* useful in its proposition to become thing that feels, it should be noted that in its entirety Perniola's book fails in its shameless androcentric, and unacknowledged masculine perspective. Perniola's proposition, that we become a post-gender, post-race, post-human 'thing that feels' can hardly be taken seriously since, in his proposition for a neuter sexuality, the author mistakes heterosexual masculinity and phallogocentricism for neutrality. This orientation is written throughout the book, evidenced in the use of the word 'man' for human, phrases such as '*our* sperm' (my emphasis) and persistent traditional masculine (hetero)sexual fantasies, as well

as the normative, masculine perspective of sex (which *The Sex Appeal of the Inorganic* sets itself up against, in a binary fashion) as it is laid out in the first chapter as the teleological reaching towards a single orgasm; 'orgasmomania'. So, although Perniola's project to 'free oneself from orgasmomania' is useful, it is hugely insufficient in that it fails to acknowledge the author's position as orgasmomaniac: Perniola perpetually writes his masculinity into thingness, refuses to acknowledge the link between his desire to become thing and his relationship to the phallic order; between wanting to be a thing and having one.

4 Fredric Jameson, *Postmodernism: Or the Cultural Logic of Late Capitalism,* Durham, NC: Duke University Press, 1991.

5 Laura Mulvey, 'Visual Pleasure and Narrative Cinema', *Visual and Other Pleasures,* Hampshire: Palgrave MacMillan, 1989.

6 See Irit Rugoff, "Smuggling' – An Embodied Criticality', European Institute for Progressive Cultural Policies, 2003, http://eipcp.net/transversal/0806/rogoff1/en

7 Steyerl, op. cit.

A CALCULATED ASKĒSIS: SERIAL EUPHORIA AND ITS LONG-TERM PROBLEMS

(VIDEO)

LODOVICO PIGNATTI MORANO AND
TRINE RIEL

Stills from *A Calculated Askēsis: Serial Euphoria and its Long-Term Problems* by Lodovico Pignatti Morano and Trine Riel

To view the video go to: https://vimeo.com/115335357

REAL ESTATE 'N' CARS

(VIDEO)

RACHAL BRADLEY

Stills from *Real Estate 'n' Cars* by Rachal Bradley

To view the video go to: https://vimeo.com/115904199

KRAUS UNCUT: SEMIOTEXT(E), DISCLOSURE AND NOT KNOWING

DAVID MORRIS

Not Knowing

So asshole, you tell me what to do. We reject all frames of reference
because they don't fit us and they're limiting but then we don't know
how to talk. Not knowing how to translate this into art is what saves us
– Chris Kraus, *Terrorists in Love* script, c. 1985

This quote comes from a damaged set of papers which I
found in the Semiotext(e) archive – I'd thought it was from
some long lost work, but Chris now informs me that it's
from the script for her film *Terrorists in Love*. Anyway, it
points towards several of the things I wanted to talk about
today, as well as perhaps some of the ways her work would
develop. In *Gravity and Grace* Simone Weil describes the
body as 'a lever for salvation' before asking the question
'but in what way? What is the right way to use it?'[1] And this
question is an ongoing concern of Chris Kraus' work – how
to use the body as this lever?

And I wanted to talk about this sense of 'not knowing', of
having little idea of what you're doing from one moment to
the next, as an artistic strategy. Speaking autobiographically,
this describes very well the way I, and most people I know,
tend to go about most things. Whether not knowing saves us
or not, it's a pretty good description of how we operate. But
then this day to day not knowing isn't what Kraus is up to. As
she has said via Alice Notley 'because we rejected a certain
theoretical language people just thought we were dumb.'
And as per the script, 'Not knowing how to translate this into
art is what saves us.' The 'not knowing' is precisely the point,
rejecting all frames of reference and translating into art and
back into life, not knowing how to talk and still talking.

I would see some form of 'not knowing' as a constant
between Kraus' work and Semiotext(e). A sense of 'not

knowing' has been a basic strategy of Semiotext(e) ever since their foundational Schizo-Culture conference in 1975 – to quote Sylvère Lotringer on that event, 'we had no idea what we were doing, and everything went wrong.' To give a brief bit of history: the Schizo-Culture conference took place in New York, in the earliest days of Semiotext(e). It began as an attempt to introduce then unknown radical philosophies of post-'68 France to the American avant-garde. The event featured Gilles Deleuze's first presentation of the rhizome concept, Michel Foucault's introduction to his great unfinished History of Sexuality project and Fèlix Guattari's attempt to put transversal structures into practice; and brought together a diverse group of activists, thinkers, patients and ex-cons in order to address the challenge of penal and psychiatric institutions. In the event it was massively over-hyped, the format broke down, speakers fought with the crowd and each other, and the event was completely out of control. It also set in motion the increasingly complex trajectory of Semiotext(e) as a messy and restless collaborative body of work.

Here's part of a letter sent in response at the time, from a therapist named Betty Kronsky:

I am grateful to you for having organized the conference, which introduced me to an important current of thought previously unknown to me [...] However, I am also left with a feeling of discomfort and sadness related to the smouldering hostilities and lack of receptivity [...] How to understand the complex phenomena of the weekend? [...] Finally, let me say that I am excited about this conference and would like to attend its sequel, where the real issues might yet be joined. Meanwhile, I am encouraged by the knowledge that I have always felt

comfortable with rhizomatic phenomena, perhaps because I am an American and a woman.

It's worth noting that the two female speakers at the conference, feminist militant Ti-Grace Atkinson and prisons activist Judy Clark – like other female pioneers of their generation – have all but disappeared from public/ intellectual life in the years since (Clark has been in prison since 1983 for being the driver in a 'Brinks' security truck heist in which a guard and two cops were killed). There is a passage of *I Love Dick* on Hannah Wilke where Kraus/ Wilke – it is unclear who exactly is talking – says 'If women have failed to make "universal" art because we're trapped within the "personal", why not universalise the "personal" and make it the subject of our art?' Or, as Catt self-deprecates in *Summer of Hate,* 'Having no talent for making shit up, she simply reported her thoughts.' Again of course, this isn't really what's going on at all, as another line from Simone Weil from *Gravity and Grace* makes clear, 'We possess nothing in the world except the power to say "I" [...] There is absolutely no other free act which it is given us to accomplish – only the destruction of the "I"'.[2] Or as Kraus via Weil puts it in *Aliens & Anorexia,* 'If the "I" is the only thing we truly own, we must destroy it [...] Using the "I" to break down "I"'. (I was happy to discover that George Bataille also described Simone Weil's later work, her mysticism, as a process of 'unknowing'.)

So the 'not knowing' is deliberate. In this sense Kraus knows exactly what she's doing. The thoughts aren't 'simply reported' but blended with criticism, theory, other writers and 'real life' persons – and even when they are reported, they come saturated with so much other stuff that tying it all to a single person is more convenience than description.

And the connection is always made between Kraus' writing, this 'subjective reporting of thoughts', and her life as lived, 'a life as material' as she has put it.

And this is also what we would expect to find in an archive – the intimate papers, the correspondence and notes, the stuff that's real, the life, as opposed to the stuff that's made up, the work. I've been working with a section of the material in Semiotext(e)'s archive for a couple of years now off and on, and it occurred to me that there's an interesting relation between Kraus' work, particularly her writing, and the archive. There is the very literal sense of her presence within that archive – her work with Semiotext(e) since the late 1980s is completely crucial here – but there is also the question of what an archive might mean with respect to a writer such as Kraus, and her approach to writing. Again, *I Love Dick* is a good example – it's a novel constructed around letters, personal letters, letters really exchanged – the book is simultaneously a performance of correspondence, a fiction, a work of theory, and an archive of real life correspondence which also happens to exist as a collection of letters in a real life archive, or hanging from a cactus outside Dick's house somewhere in the Antelope Valley desert.

So one of the important things about Kraus' work is how it mangles these simplified versions of how subjects, selves, real, fictional, public and private... how they operate, how they are far more strange and messy. This is why it seems to me wrong to call her work autobiographical – in the sense that, really, most of the time autobiography really isn't interesting at all. As Foucault says in an interview,

> ...my personal life is not all that interesting. If somebody thinks
> that my work cannot be understood without reference to such

and such a part of my life, I accept to consider the question. (Laughs.) I am ready to answer if I agree. As far as my personal life is uninteresting, it is not worthwhile making a secret of it. (Laughs.) By the same token, it may not be worthwhile publicising it.[3]

John Rajchman – also part of the early Semiotext(e) collective as a grad student and co-organiser of Schizo-Culture – notes that 'it is remarkable how much of what is known of Foucault's philosophy comes from his interviews.'[4] In the quoted conversation we also learn that Foucault enjoys club sandwiches and ice cream – he compares these pleasures to one of his 'best memories' of being hit by a car on a sunny day – he prefers drugs to wine, he has a white apartment... we don't learn much, which is all to the good. Talking about the personal requires a certain level of abstraction, through its relation to other narratives, structures, ideas and things in order to become interesting: an 'I' thoroughly embedded in a mess of social and cultural forces.

So Kraus' proposal of herself as a case study is the point – she provides the material, which is the closest that happens to be to hand, but in this sense the books are not about her at all. In this way, her work with Semiotext(e) as writer and editor – also continues to expand and complicate the ongoing concerns of the press. It has been suggested as a putting-into-practice some of the ideas of the thinkers Semiotext(e) began publishing during the '70s and '80s, but also fundamentally in terms of her role as editor – again, the body as a lever – this time onto the way that Semiotext(e) actually developed.

Disclosure

...it is very hard to 'explain oneself' - in an interview, a dialogue, a conversation. Most of the time, when someone asks me a question, even one which relates to me, I see that, strictly, I have nothing to say
– Gilles Deleuze, *Dialogues,* 1977

The interview is a format that Semiotext(e) has returned to throughout its history, from its earliest publications – the very first instance of what we now know as 'French theory', according to Lotringer, was a set of interviews republished in one of the earliest Semiotext(e) collections in 1976 or so.

So this kind of disclosure via interview was a formative part of the press for several important reasons. And Kraus' work has altered the trajectory of this – for one thing where these disclosures spoke to a sense of spontaneity, of live thought and dialogue, Native Agents revealed what was missing from that dialogue. This shift might also be understood as a kind of blurring of textual or theoretical concerns into embodied experience, a kind of thinking through doing.

It's worth adding that the press took a further turn in the 2000s when Hedi El Kholti joined as co-editor, expanding an existing line in queer writing old and new, from Tony Duvert to Abdellah Taïa, and setting up the in-house 'zine *Animal Shelter.* And so Semiotext(e) is best understood as a collision of these various sets of personalities and interests, an ongoing project.

The Native Agents series of books was set up in the late '80s. Kraus has said that Native Agents began as an attempt to articulate 'a very public female "I" [...] the same public "I" that gets expressed in these other French theories.'[5] To Michelle Tea, also a Native Agents author, she explains further,

All the books but one are female, and all of them were written in the first person [...] They were hypernarratives, adventure tales involving travel, petty crime, drug dealing, media witch hunts against lesbians, prostitution as lived and told by comic antiheroes. This, finally was something new and radical. The female 'I', which had been so sanctimoniously portrayed in female memoir, became a much more public 'I': one that could be just as contradictorily fucked-up as all the guys.[6]

(N.B. This is taken from a news publication, *The San Francisco Bay Guardian*, but if you look at the punctuation here again, the speakers blur together.) So in terms of Semiotext(e)'s history, the series was a deliberate response to them 'missing' feminism during the '70s and '80s, in favour of books by white European males; but rather than engaging in an exercise of self-critique, Kraus took a pragmatic approach, to redress the balance and move forward beyond that critique. Given that what we know as 'French theory' was invented in the USA, it also makes perfect sense that Semiotext(e) would begin to publish home-grown equivalents – and just as the philosophy didn't look like philosophy, the fiction didn't look like fiction.

A problem perhaps with universalising the personal (particularly now, as opposed to the 1970s, or even the 1990s) is that the subjective voice is so commonplace: any kind of oppositional 'I' will be in danger of dovetailing neatly with the mainstream. Except this seems exactly the point – which would fit with the general strategy of Semiotext(e) – that, rather than adopting a position of critical distance, the books engage directly with, against, and through the popular 'I'. Better to push it to its limits, to merge with and complicate this 'I' from within.

Anti-confessions

We already heard in Karolin's and Jesse and Beth's talks how Kraus' work runs counter to the confessional, the ultimate disciplinary form of writing. This is following Foucault's *History of Sexuality* in which he describes how confession was used during the Catholic Reformation to control sexual behaviours within a community. This also occurs, incidentally, in Fanny Howe's 2000 novel *Indivisible*, another Native Agents text. The word 'disclosure' is better, because it has more of a blankness about it – confession seems tied up with therapy, guilt, or catharsis. But there is lots of overlap, and 'confessional' selves are nonetheless real and important in all kinds of ways for all kinds of reasons.

Even so I would like to suggest that Kraus' work is better described as anti-confessional. To explain what I mean, I want to tell a short story about the late life breakdown of Jean-Jacques Rousseau.

With his *Confessions*, Rousseau shaped what we know as modern autobiography; it is one of the first extended non-religious explications of a personal subjectivity in western literature. And Rousseau's discovery of self coincides with his discovery of the imaginary, of fiction: 'it is from my earliest reading that I date the unbroken consciousness of my own existence [...] I became the character whose life I was reading.'[7] *Confessions* is credited with locating the paradoxes between private and public selves, Rousseau moves between strata of high and low society at the same time as marking himself off from the social body and affirming his own separation. Sincerity was crucial to Rousseau's project, as it is for Kraus and Semiotext(e); public disclosure as a means to bring the reader closer. At the same time Kraus' Native Agents 'I' would be better

situated at the opposite end of these contradictions. Just as Rousseau is retreating inwards from a culture of the public/ professional self, they are pushing back outwards from a culture of entrenched individualism, trying, as Kraus and Lotringer have put it, to 'see what they can do with this fucked up American subjectivity, and get out of it, and look at the world.'[8]

But Rousseau never finished the *Confessions*. He was disappointed by their reception and withdrew to work on a different project, *Rousseau, Judge of Jean-Jacques*, also known as the *Dialogues*. This text was written over a four-year period of isolation: Rousseau trusted even his closest friends so little that he chose not to show it to anyone – finally he tries to leave it anonymously on the altar at Notre Dame cathedral, but finds his way in blocked. He says it is a sign that even the heavens were against him.[9]

So unlike the first person *Confessions*, the *Dialogues* is more psychologically fragmented – in a preface Foucault actually described it as the anti-*Confessions* – it features several characters, all versions of Rousseau discussing and arguing amongst each other, in defence of the real life author's reputation. This book has mostly been ignored by critics, except to point out just how crazy Rousseau became.

But the *Dialogues* are also perhaps the logical conclusion of Rousseau's *Confessions*. His 'retreat inwards' ends up in isolation, paranoia and surface, but also an 'I' that is opaquely dispersed across several bodies. If, as Carol Lazzaro-Weis writes of Italian feminist authors, the confessional mode allows 'an analysis of their own myths of wholeness and integrity',[10] the anti-confessional might allow anti-mythical selves to be produced. And if the confession displays how identity is social, communal, or political, the anti-confession – as exhibited in Kraus' work –

is a means to dissolve and redistribute identity across these social, communal, or political bodies.

It's almost too perfect that during the writing of the *Dialogues* Rousseau took refuge in Britain with David Hume. They quickly fell out, with Rousseau accusing Hume of being part of the conspiracy against him. But in his *Treatise* Hume reaches an equally radical conclusion – turning inward in search of his most intimate self, he comes up empty handed – he finds 'nothing but a bundle or collection of different perceptions, which succeed each other with an inconceivable rapidity, and are in a perpetual flux and movement.'[11]

So to finish I'll come back to that *Terrorists in Love* script again – 'So asshole, you tell me what to do. We reject all frames of reference because they don't fit us and they're limiting but then we don't know how to talk. Not knowing how to translate this into art is what saves us.' And so one way Kraus' work and Semiotext(e) collide is as a response to an exclusive language, an attempt to destroy a stable 'I' that doesn't make sense – reacting to frames of reference that don't fit by producing new ones, without knowing exactly how.

And then there's this passage from Clarice Lispector's book *The Apple in the Dark* – in some ways totally unrelated but somehow a perfect fit. Where 'non-identity' and 'not knowing' are by-products of a deeper understanding, why bother to translate into some more superficial version, a compromised language. She writes via a character who is 'on strike from being a person':

He was constructing a dream – which was the only way in which truth could come to him and he could make it live. Was it indispensable, then, to understand perfectly what was

happening to him? If we understand it deeply, do we also have to understand it superficially? If we recognise our own taking on shape through its slow movement – just as one recognizes a place where he has been only once before – is it necessary to translate it into words that compromise us?[12]

Footnotes

1 Simone Weil, *Gravity and Grace*, UK: Routledge, 2002.
2 Ibid.
3 Sylvère Lotringer (ed.), *Foucault Live: Interviews 1961-84*, USA: Semiotext(e), 1996.
4 John Rajchman, 'Crisis', *Representations*, Fall 1989, no. 28.
5 Henry Schwarz and Anne Balsamo, 'Under the Sign of Semiotext(e): The Story according to Sylvère Lotringer and Chris Kraus', *Critique: Studies in Contemporary Fiction*, 1996, vol. 37, issue 3.
6 Michelle Tea, 'Constructing Semiotext(e)', *SF Bay Guardian Literary Supplement*, clipping from Semiotext(e) archive.
7 Jean-Jacques Rousseau, *Confessions, Book I*, London: J.M. Dent, 1960. As discussed in Starobinski's *Jean-Jacques Rousseau: Transparency and Obstruction*, Chicago: University of Chicago Press, 1988.
8 Quoted in John Strausberg 'Radical Thought', *New York Press*, 19 February 2002.
9 This is described in Rousseau's afterword to the *Dialogues*.
10 Carol Lazzaro-Weis, *From Margins to Mainstream: Feminism and Fictional Modes in Italian Women's Writing 1968-1990*, USA: University of Pennsylvania Press, 1993.
11 David Hume, *A Treatise of Human Nature*, Oxford: Clarendon Press, 1896. Available online at http://archive.org/details/treatiseonhuman00humegoog
12 Clarice Lispector, *The Apple in the Dark*, UK: Haus, 2009.

PHILOSOPHERS ENOWNING THAT THERE BE NO OWN (FACE)

JONATHAN LAHEY DRONSFIELD

reading Kraus' *I Love Dick* distractedly uninterested in what it might be saying about schizophrenics i pictured the kind of blog i might make – two columns – were it philosophy and its other its outside philosophy outside of itself where the outside shows something about the inside that the inside is blind to – "'and who are you?' Brion Gysin's question, asked to ridicule the authenticity of authorship" [232] re-claimed me – as it happens I had just been looking at Gysin's *The Third Mind* and found easily the relevant passage – "Poets have no words 'of their very own.' Writers don't own their words. Since when do words belong to anybody. 'Your very own words,' indeed! And who are you?" – no sooner does he say this than orders "CUT THE TEXT INTO THREE COLUMNS" – picking up Kraus' book two weeks later i see that i have earmarked an earlier page – "Gysin and William Burroughs recorded their experiments in time-travel via an awareness of coincidence" [222] – and outlined there is another three columned imperative – record what you are doing thinking reading – again I 'self-helped' the book *The Third Mind* and read that this second three column way is Burroughs' and not quite as Kraus tells it – the first column is not so much what you're doing as what happened – and whilst the second is thinking it is also memory "activated by my encounters" – such are the only two mentions of Gysin and Burroughs in *I Love Dick* – two sets of three columns – one a principle for disorganising already written texts – the other a method for organising the writing of texts – both occurring in sections of the novel devoted to discussions of schizophrenia –

i knew finally that she had realised i did not love her from how she fell on to the bed – it was as if she were aligning herself on a stranger's couch fighting to keep herself as straight as possible to spite the pain which would double her up were she now in my arms on our rose of lovers – I looked at her face – she appeared feverish – I would later hear that she was hallucinating just then and in her words to a face behind her face – I had taken away her power to love – in displacing her face from itself I had stripped her of what was least her own for its being once mine – mine to gaze at to wander and to touch – and in touching to give back to her in the form of my love – not her own for she could no more dictate her face than she could renounce the words she used to lay claim to the truth of her own appearance beyond her face – since even that renunciation would be uttered in the name of the same truth – words she used in discovering them in sex together – words to acknowledge that her face was not hers but mine – an acknowledgement that was nothing but love in its dispossession – and now she had lost that face which was least her own – it had disintegrated had particled and now she was having to live with the swirl of that face behind her face – and if at that moment she knew she was not anywhere if she was aware that she had nowhere to be then it was because her face was no longer recognised as least of all hers to own and precisely in virtue of that hers to have given as an act without action every day to her lover – her face was now no longer to come but one which had passed –

what sense does it make to say 'know your face'? to know your own face in order to disown it to throw it off your head not out of the hole in your head but your face off your head for out of the head implies a hole in the head and that hole in the head would be part of the face and thus to throw the face out of a hole in the face is to throw the face back onto itself in the form of a mask disclosed in the hand – then out of a hole in the back of the head a segment cut from the back of the head out of which to draw the face – but then the others might look in and the one thing I could not do would be to see that looking in – I'd miss witness – the spectacle would not be mine to witness – Deleuze & Guattari argue that in order to desubjectify the self one must know one's face as a stage on the way to disorganising it and setting free one's faciality traits from the codes it inherits or has imposed upon it. But one can no more set the traits of one's own face free than one can wilfully seal them to a fixed landscape of surety and contentment. One's face is one's ownmost yet it is not one's own. Not one's own in the sense that it is already ahead of one before one gains a sense of knowing that one's face is one's own. One's face is at once both immanent and transcendent: immanent to oneself and transcendent to whatever self might be gained by having a face. Immanent to oneself in being none but my own, yet absolutely exterior, absolutely exterior to none but me. For it is not exterior to my lover, she who touches it and in touching it gains herself in me. Transcendent in that one's face is one's own in dispossessing me and only me of the facility to organise it. And thereby do I gain the power to speak: language. Language is the only possible way in which we can 'set free' the traits of the face. For words are the making sense, indeed the sense, of one's face. A face behind the face in the sense that we can with words thrown ahead, further ahead than the face throws itself, a sense of what is beyond one as one's self. And if art can do this it is not because it is faceless, it is because it is able to organise the face and disorganise the face by separating the face from the principle of ownership.

Have a gift for lock flows without any spocan unlock. Any codics can instantly sit. Sires their weaknesses. Schitzy word. Both suddenly burst out with life, things that you wo.. will tell you in the absolutely secret. Fé and him into themselves. Gets creamy like a librous of scholars. Becau.. just formulate obserperson's expectations. ".. ," Félix continued, "makes them part of hisst power: the schizo through his or her be solution?ing into other people's schizophrenicken language. Like the minds. Direct current just by reaching into a robot thatuate a person: their machine. Schizophrenand expectations and thoughts and their denoun and verb?? "The isn't "situation" such the most incredible schizophrenic ... will'ld never imagine any details of your private most abrupt way truths one could know. And he, licks, said in an interview, that you believed to be (*Chaosophy*), schizo with her associatively. They're phrenics aren't sunrary. And schizophren- hyperactive. The world use they're emotionally ics are the most gene. ..'ve they're willing to *right there.* They don't. The schizophrenic has become the situated. He internalizes all the lightning access to you. Subjective system. This links between you. Marenic turns into a seer, is empathy to the high coming. But when does then enacts that vision empathy turn into diss

CHRIS KRAUS READING
FROM
ALIENS & ANOREXIA
(AUDIO)

Cover image of *Aliens & Anorexia*, 2013 edition

To listen go to: https://soundcloud.com/mute-magazine/
ck-audacity-kraus-rca-mp3

Recorded at the Royal College of Art London, 13 March 2013.

CONTRIBUTORS

SAMIRA ARIADAD is an activist working with the Swedish anarchist magazine *Brand*, writer, musical saw player and philosophy student.

RACHAL BRADLEY is an artist who works with image, writing and installation, currently living and working in Glasgow. Her work concerns the area of contemporary art image, its circulation and accumulation as meaning, a medium for the interchange between use-value and exchange. Most recently her work was included in the following exhibitions: Waste Not, Galerie Gregor Staiger, Zurich (2013); Interiority Complex, Cubitt, London; Strohwitwe, 24 St. Vincent's Crescent, Glasgow; That is the Dawn, Galerie Gregor Staiger, Zurich and LABOUR, Kunsthall Oslo, (all 2012). With artist Matthew Richardson she co-founded and runs OHIO, a gallery in Glasgow.

BETH ROSE CAIRD studied Fine Art at the Victorian College of the Arts. She is an emerging writer and artist based in Melbourne, Australia.

JESSE DAYAN is a Melbourne based contemporary artist. He has previously been a finalist in prizes including The Arthur Guy Memorial Art Prize and The National Works on Paper Award. He has been shortlisted for the Brett Whiteley Traveling Art Scholarship and the Australia Council Kunstlerhaus Bethanien Residency.

JONATHAN LAHEY DRONSFIELD is Associate Professor of Theory and Philosophy of Art at the University of Reading. Other performative readings from *Philosophers enowning that there be no own* and another major art publication he is currently working on, *The Swerve of Freedom After Spinoza*,

have been given recently at SMAK, Extra City, Stroom, Wilkinson, Rietveld, Focal Point, Institut Francais and IKEA Ashton-Under-Lyne.

TRAVIS JEPPESEN is based in Berlin and London, where he is a PhD candidate at the Royal College of Art. His writings on art, literature and film regularly appear in *Artforum*, *Bookforum*, *Upon Paper* and *Art in America*. Jeppesen's latest novel is *The Suiciders* (Semiotext(e)/MIT Press).

MIRA MATTAR is a writer and contributing editor at *Mute* and *3:AM*. She lives in London.

KAROLIN MEUNIER is an artist and writer living in Berlin. Parts of this text have been published in her book *Return to Inquiry* (2012) in a translation by Lucy Powell. Meunier has recently co-edited the German translation of Chris Kraus' novel *Torpor* for b_books in Berlin.

LODOVICO PIGNATTI MORANO is a writer. His first novel *Nicola, Milan* was published in 2014 as part of Semiotext(e)'s Native Agents series. He lives in Milan.

DAVID MORRIS is based in London. With Sylvère Lotringer he has recently co-edited the double volume *Schizo-Culture* (Semiotext(e)/MIT).

HESTIA PEPPÉ is an artist, a writer and a governess, who situates herself – weedlike – in the cracks and thresholds between disciplines. Peppé completed her MFA in Computational Studio Arts at Goldsmiths in 2011. Previously she studied Drawing at Camberwell College of Art and graduated in 2005. Since then she has been working with

political and aesthetic issues emerging as a result of the development of social media in the fields of performance, technology and mediation. Her work is informed both by her early experiences in experimental communities and by her formal training in drawing and computation.

TRINE RIEL has written for several Danish national newspapers on subjects including Athenian philosophy, antinatalism and TV. She is currently undertaking a practice-based PhD programme at The Huston School of Film and Digital Media, National University of Ireland, Galway.

HELEN STUHR-ROMMEREIM is an editor at *Full Stop*, and a founding editor of *Fungiculture*, a psychedelic journal of cultural studies. She lives in Philadelphia.

LINDA STUPART is an artist, writer and educator from Cape Town, South Africa. She is currently undertaking a PhD in Art Practice at Goldsmiths College engaged in issues of objectification, and is Associate Lecturer at London College of Communication. http://www.lindastupart.net

Lightning Source UK Ltd.
Milton Keynes UK
UKOW04f2101291115

263783UK00001B/11/P

9 781906 496647